SAN FRANCISCO
THROUGH TIME

CATHERINE ACCARDI

AMERICA
THROUGH TIME®
ADDING COLOR TO AMERICAN HISTORY

America Through Time is an imprint of Fonthill Media LLC
www.through-time.com
office@through-time.com

Published by Arcadia Publishing by arrangement with Fonthill Media LLC
For all general information, please contact Arcadia Publishing:
Telephone: 843-853-2070
Fax: 843-853-0044
E-mail: sales@arcadiapublishing.com
For customer service and orders:
Toll-Free 1-888-313-2665

www.arcadiapublishing.com

First published 2020

ISBN 978-1-68473-003-2

Typeset in Mrs Eaves XL Serif Narrow
Printed and bound in England

INTRODUCTION

San Francisco Through Time is the story of the city's journey through time, beginning with images and text describing the evolution into one of America's most historic and captivating urban centers. Cities expand, changing form and structure throughout their existence, so let us consider the city a living organism and a reflection of its people.

Images have a unique way of depicting urban fabric, fabric where change is a constant. Depicted will be buildings and places that have disappeared, as well as buildings that have not changed, remaining a stalwart landmark of history, unwavering against the changes of time. Among those are the Palace of Fine Arts, the Palace Hotel and Ghirardelli Square—examples of how historic preservation can be utilized to give a city a sense of permanence.

Where did the city of San Francisco have its beginning? During prehistoric and early historic times, a large marsh protruded inland south of Rincon Hill as far west as Seventh and Mission Streets. Prehistoric mounds, containing artifacts dating back 2,000 years, were found at Hunters Point. The people of these mounds may have been the ancestors of the Costanoans, as the Spanish named the coast people. Aboriginal inhabitants, the Muwekma Ohlone tribe, consider the San Francisco area as their original homeland.

In 1769, Gaspar de Portola's expedition first observed San Francisco Bay. Historic accounts indicate the first Europeans sailed into San Francisco Bay in 1775 and the first landing is thought to have occurred on the northeastern tip of the San Francisco peninsula, a rocky outcropping below Telegraph Hill, at what is now Broadway and Battery Streets, later named Clark's Point.

Ohlone lived in several small villages when Europeans first arrived and historic accounts indicate a Native American settlement might have existed in the northeast quadrant of the peninsula. Although no officially designated landmarks can be attributed to these Native Americans, the first designated local landmark, Mission Dolores, was constructed, in part, with Native American laborers.

A number of Native Americans and Spaniards occupied the area around Mission Dolores.

The Mission was founded on October 9, 1776 by Francisco Palóu, a companion of Junípero Serra. A plank road connected the Mission settlement to the hamlet located at the shoreline of Yerba Buena Cove. The cove extended from Clark's Point to the north (southeast of Telegraph Hill, near the corner of Broadway and Battery Streets) and Rincon Point to the south (near the corner of Harrison and Spear Streets). The cove's beach was set back as far as what is now Montgomery Street between Clay and Washington Streets.

The area's population in the 1830s numbered around 350 people scattered amongst the sandhills. By 1849, after the discovery of gold in the Sierra foothills, the population grew to 25,000, placing the peninsula in the path of hundreds of people seeking a new home and new opportunities and a better life. Geographic positioning, relatively mild climate, centrally located harbor and the type of transportation of that period, placed the peninsula in a position to offer characteristics needed by the population at that time. Yerba Buena, Spanish for "good herb," was the name given to the early settlement. On January 30, 1847, Spaniards renamed the hamlet San Francisco, Spanish for "St. Francis."

Captain William A. Richardson arrived in California and was made captain of the port. He built a residence on Dupont Street, the area that is now Grant Avenue, between Clay and Washington Streets. His house was a combination of house and tent and the first dwelling to be located in San Francisco.

Richardson acquired a neighbor one year later when Jacob Primer Leese arrived from Ohio in May 1836. At one point he constructed, what was called at the time, a "mansion" of 60 feet by 25 feet, near Captain Richardson's tent at a location bounded by today's Stockton, Grant, Sacramento, and Clay Streets. Leese's residence was completed on July 4, 1836, and Richardson and Leese threw a party to celebrate Independence Day, making it the first celebration of Independence Day in San Francisco. Some historians consider these two specific structures as the origin of the City, although, in 1836, the new village consisted of thirty or forty houses, located in the sandhills around the present Portsmouth Plaza.

Leese built another structure in 1838 at today's intersection of Commercial and Montgomery Streets. Richardson also improved his structure to an adobe dwelling on his original site. His *Casa Grande* was described as the most "pretentious" structure in town.

The first town site was plotted in October 1835 by Francisco de Haro, the *alcalde* (mayor) residing at Mission Dolores. The town was laid out in 1839 as a twelve-block area plotted by Captain Jean Jacques Vioget, roughly bounded by Pacific Avenue on the north, Sacramento Street on the south, Dupont Street on the west, and Montgomery Street at the east. At that time, Montgomery Street was at the shoreline.

The day was July 9, 1846, when the USS *Portsmouth* landed at what is now the southeast corner of Montgomery and Clay Streets. The ship's captain, John B. Montgomery, raised the American flag in the small community square one block away. This square is now Portsmouth Plaza, named in honor of Montgomery's ship.

Considered the first thoroughfare in San Francisco, *Calle de Fundacion* (Spanish for "Street of the Founding" or "Foundation Street"), was adjacent to Richardson's tent and

ran northeast from the village of Yerba Buena, beginning near the corner of Kearny and Pine Streets, towards the north beach. The street was laid out in October 1835 by Alcalde de Haro. In 1847, *Calle de la Fundacion* was renamed Dupont Street after a Naval admiral, and in 1886, the southernmost portion renamed to Grant Avenue. After the 1906 earthquake, the entirety of Dupont Street was renamed to Grant Avenue after President Ulysses S. Grant.

The first set of images in *San Francisco Through Time* are those of Mission Dolores, the oldest existing building and first officially designated San Francisco landmark. After recognizing this important historical location, we will visit the northeast quadrant at the site of what was then the center of the village. We will look at the area around 823 Grant Avenue, the location of Richardson's tent near the first official street where a plaque now marks the spot. Images of Portsmouth Plaza will highlight the early part of our journey meandering through the oldest section of San Francisco.

The journey will move through the North Beach District where bay waters reached the north beach at what is now approximately Bay and Powell Streets. Soon, the area became one of the most colorful sections of the city, inhabited primarily by Italian and Swiss immigrants, establishing their culture still evident today.

This enclave, known as Little Italy, provided newly arrived immigrants with a place to call home. The first major wave of Italian immigrants arrived for the Gold Rush in the early 1850s. At that time, approximately 230 Italians lived in San Francisco. Those who came for the Gold Rush quickly moved into the real estate, service, and fishing industries. By the 1870s, Italian fishermen provided 90% of all fish consumed in San Francisco. Fishing in in the city was an important industry, as more fish were sold from San Francisco than at all other West Coast ports combined.

Rickety wooden dwellings clung precariously to Goat Hill (later renamed Telegraph Hill). Some of these dwellings still exist today, but this real estate, once ramshackled, is now valued at several million dollars. We shall see those dwellings transform through time in contrasting images.

We will visit several of the many hills that dot the city and explore the central business district and Market Street where citizens knew how to build thriving enterprises of all sorts. World-famous hotels like the Palace and St. Francis offered luxury accommodations. The City of Paris department store clothed many a high society socialite, some of which lived on Nob Hill, one of the swankest addresses in the city. Splendid reminders of the city's elegant past continue to adorn Nob Hill illustrated by the well preserved structures of the Flood Mansion and Fairmont Hotel.

Expansion west and south was just around the corner and so we shall travel westward towards the Pacific Ocean where numerous wondrous sights were located. As early as 1863, the Cliff House was just that, a structure that gripped the cliffs over the Pacific Ocean. Ocean Beach beckoned folks to enjoy sand and surf. Crowds of people flocked to Playland at the beach. Further down the Great Highway, Fleishhacker pool drew thousands of fun-loving people. Residents and visitors were stunned by the lush beauty of Golden Gate Park and its many attractions.

How appropriate to end with images of the iconic Golden Gate Bridge. This landmark signals the entrance into San Francisco Bay where all the ships, 500 of them at one time, made their way. These vessels carried the founders of San Francisco.

San Francisco was, and still is, all-inclusive with just a few miles separating the likes of the Pacific Ocean, Pacific Heights, and the outer lands of the Hunter's Point Naval Shipyard and India Basin. We will even take a peek at the famous Albion Brewery established in 1870 and still standing in the southeast quadrant—not as a brewery, but now as a million-dollar residence.

It is not just visitors that marvel and enjoy the positive experiences of San Francisco; residents adore their city, many saying they would not live anywhere else. The attributes of this city are expressed by its stunning topography, neighborhood culture, the arts, and a unique array of architectural styles, just to name a few.

Statistically, San Francisco is exactly 47.355 square miles in size with a city limit that extends 32 miles out into the Pacific Ocean, because the boundaries of the city and county of San Francisco include the federal property of the seven Farallon Islands. At the time of writing, the city could claim over 400 officially designated city, state, and national landmarks, some of which you will see in this book.

On its many hills, with once boggy roads and ramshackle dwellings, the hamlet is now a sparkling jewel that juts out into San Francisco Bay. It is the City by the Bay, a city that offers quite a remarkable journey through time.

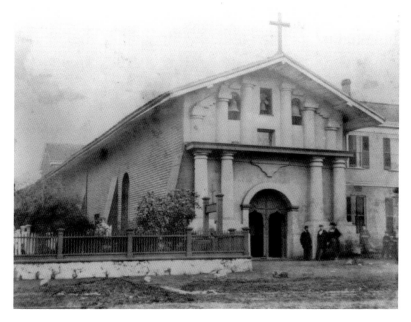

MISSION DOLORES: The oldest existing building in San Francisco, and the first structure to be designated an official San Francisco landmark, is Misión San Francisco de Asís. The Mission was founded in 1776 by Spanish Franciscan missionary, Francisco Palóu. The church itself was built between 1782 and 1791 with sun-dried adobe brick, four feet thick. It has stood on Dolores Street for more than 244 years. [T: LOC] [B: CA]

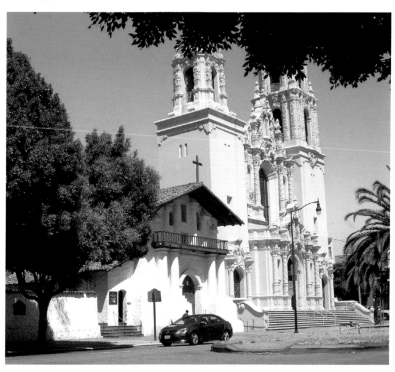

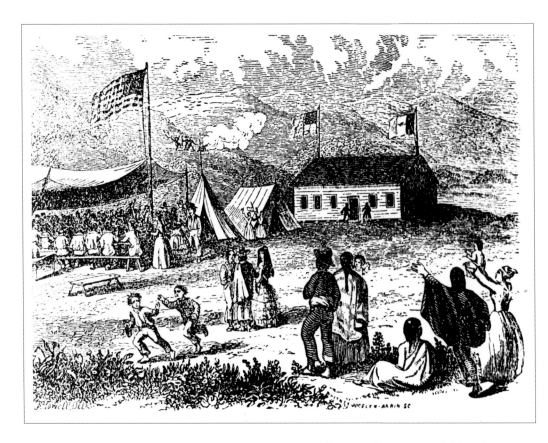

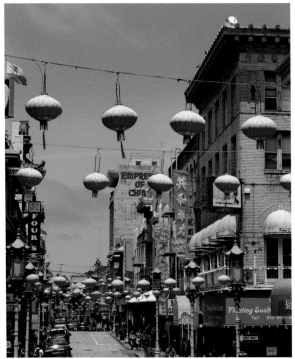

CAPTAIN RICHARDSON'S TENT/
JACOB LEESE HOUSE: British officer
Richardson arrived in San Francisco
Bay on the ship *Orion* in 1822. In 1835,
he erected a structure described as:

" ... a large tent, supported on
four redwood posts, covered with
a ship's foresail," in the area now
bounded by Grant, Stockton, Clay,
and Washington Streets. In 1836,
San Francisco pioneer and second
permanent resident, Jacob Leese,
built the first permanent house
at what is now Grant Avenue and
Clay Street, described as, "one story
with gabled roof, framed, made of
clapboard." The image depicts a
celebration on July 4, 1836. The area is
now adjacent to Portsmouth Plaza and
a PLAQUE AT 823 GRANT AVENUE MARKS
THE SPOT. [T: LOC] [B: LOC/CHA]

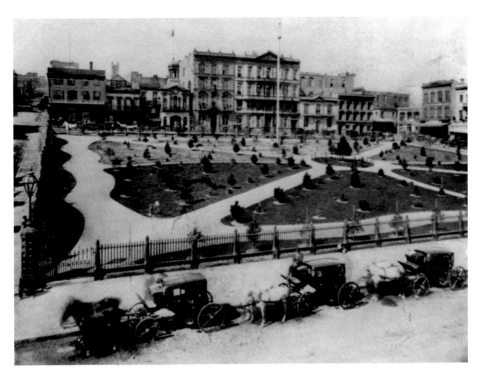

PORTSMOUTH PLAZA: The plaque at the plaza, bounded by Kearny, Clay, and Washington Streets reads: "On this spot, the American flag was first raised in San Francisco by Commander John B. Montgomery, Captain of the ship Portsmouth, July 9, 1846." As the site of the first public school building in 1847, and the first public square in San Francisco, it has been a neighborhood park for over 170 years. [T: LOC] [B: CA]

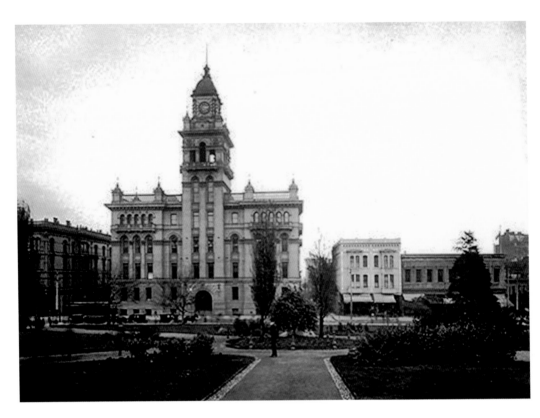

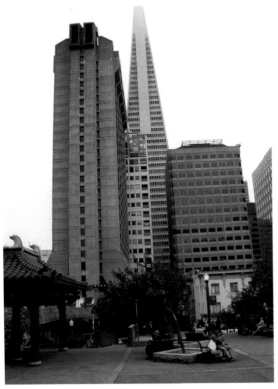

HALL OF JUSTICE: Portsmouth Plaza was vital to the city's growth. Both images are taken from across Kearny Street within the plaza and succinctly illustrate the dynamic changes befalling historic San Francisco. The hall was damaged after the 1906 earthquake. A new Hall of Justice was constructed in its place at 750 Kearny, which, in turn, was demolished in 1968 and replaced with a Hilton Hotel. [T: LOC] [B: CA]

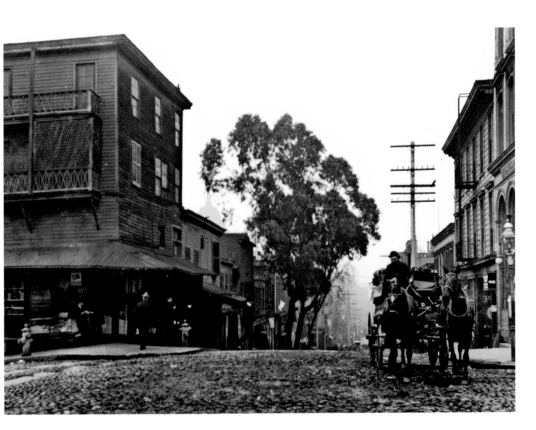

Calle de la Fundación/Dupont Street/Grant Avenue: *Calle de la Fundación* is Spanish for Foundation Street or Street of the Founding and is considered the first main thoroughfare in the city. It was later renamed Dupont Street after Captain Samuel F. Dupont, and eventually renamed Grant Avenue in honor of President Ulysses S. Grant. It is still an important street through the city's Chinatown and continues through the high-end downtown shopping district. [T: LOC] [B: CA]

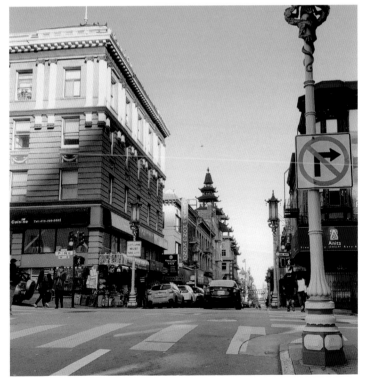

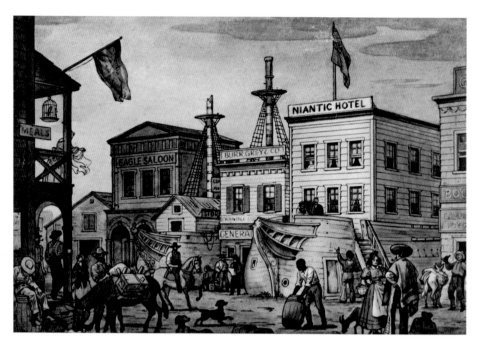

THE SHIP *NIANTIC*: One of the ships that brought people to Yerba Buena was the *Niantic*, arriving from Panama into San Francisco Bay in 1849. After depositing 248 gold seekers, it was beached at the corner of Clay and Sansome Streets at a time when the shoreline extended further inland. The hull was divided into warehouses until burning down to the hulk in the San Francisco fire of May 1851. Historic accounts indicate a number of abandoned ships still lie under parts of the city. A modern high-rise now occupies this site. [T: LOC] [B: CA]

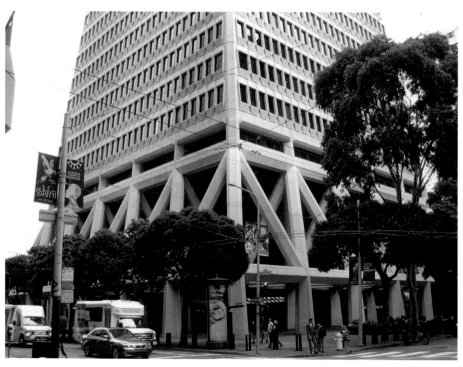

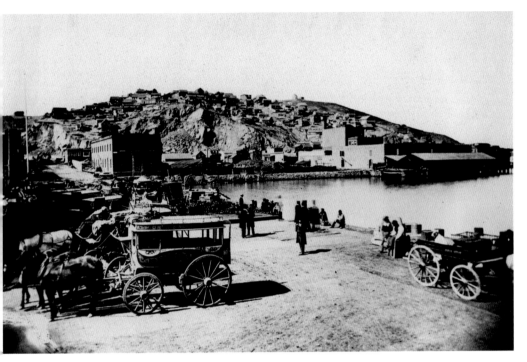

VALLEJO STREET WHARF: Comparing these two images, one might say they are unrecognizable. Wharves along the waterfront provided the city with an important source of income: the import and export of goods and freight. The Vallejo Street Wharf, pictured here in 1865, extended east into the bay from Battery Street with Telegraph Hill rising in the distance. Long gone, the area is filled in with streets and structures. [T: LOC] [B: CA]

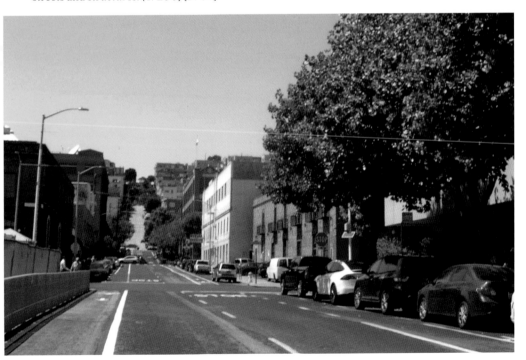

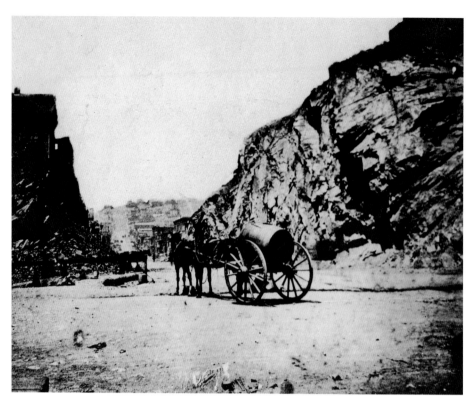

THE DEEP CUT—BROADWAY NEAR MONTGOMERY STREETS: Quarrying of Telegraph Hill caused this shocking change to the Hill. Once an impressive mass of rock and soil, the outcropping was demolished, ongoing here, in 1864, to make way for the roadway called Broadway. Quarrying of the hill was used for various purposes, including sea walls that required tons of rock. Broadway is now a main east–west thoroughfare. [T: SFPL] [B: CA]

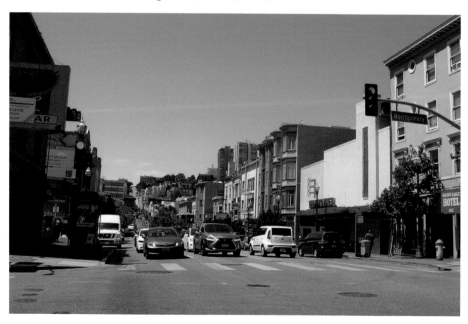

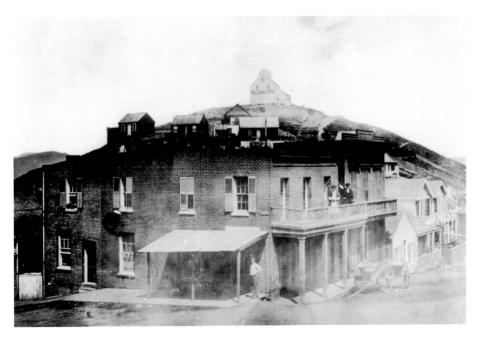

TELEGRAPH HILL—UNION & MONTGOMERY STREETS: The 1882 image is of 1301 Montgomery with Telegraph Hill and the original observatory in the background. The side of the observatory reads "telescope" in large letters. The structure is possibly the oldest brick building in San Francisco, and one of the first structures built around 1850. Having gone through many owners, it was a grocery store from approximately 1854 to the 1880s. In 1915, the building housed a barbershop, a pool hall in the 1920s, and, finally, a residence. [T: SFPL] [B: CA]

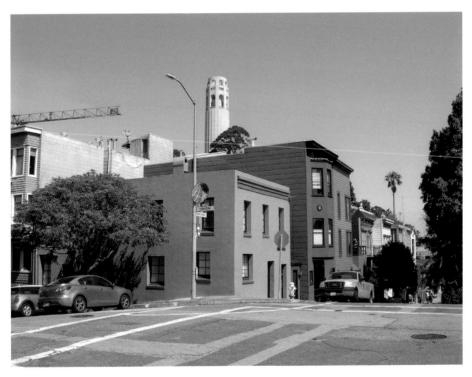

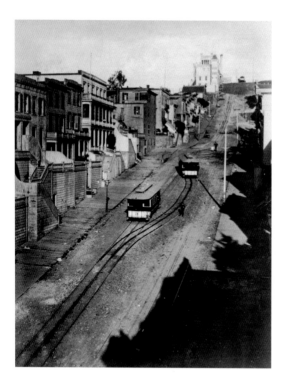

TELEGRAPH HILL CABLE RAILWAY:
This is one of the ways people
trekked up Telegraph Hill in 1884.
It was a funicular railway using two
cars attached to a cable, the idea of
Frederick O. Layman, who expected
hundreds of people would flock to
the top of the hill to enjoy the resort
and Pioneer Park Observatory. Many
of the City's railways are a thing of
the past. [T: SFPL] [B: CA]

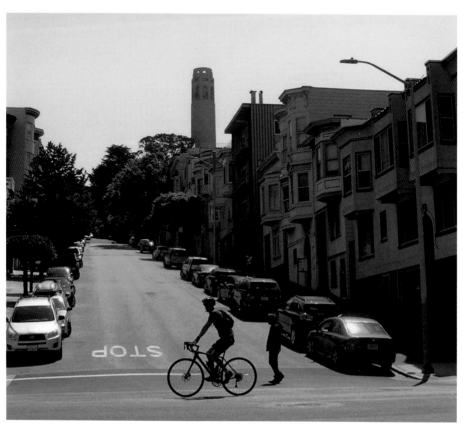

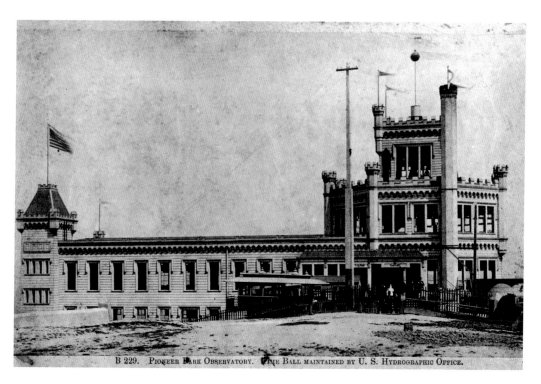

B 229. PIONEER PARK OBSERVATORY. TIME BALL MAINTAINED BY U. S. HYDROGRAPHIC OFFICE.

PIONEER PARK OBSERVATORY/
COIT TOWER: What did the top of
Telegraph Hill look like before Coit
Tower? Here it is *circa* 1884 with the
Pioneer Park Observatory, also known
as the German Castle. A cable car has
unloaded passengers posing for the
photographer. Fredrick O. Layman built
the observatory in a German baronial
castle architectural style. Opening in
1882, it had a restaurant, concert hall,
and cable car service. Interest waned and
the structure burned down in 1903. It is
now the site of Coit Tower, with public
transit service provided by the San
Francisco Municipal Railway No. 39 bus.
[T: SFPL] [B: CA]

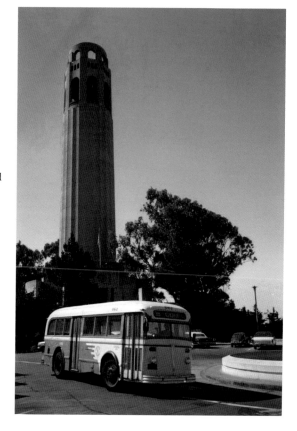

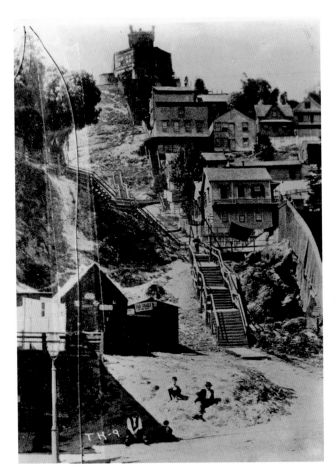

TELEGRAPH HILL AT SANSOME & GREENWICH STREETS: What a trek up those rickety wooden stairs! Several people pose for the photographer and on the way to the top of the hill are numerous shacks and cottages. Atop the hill is the Pioneer Park Observatory, now replaced by Coit Tower and expensive real estate. [T: SFPL] [B: CA]

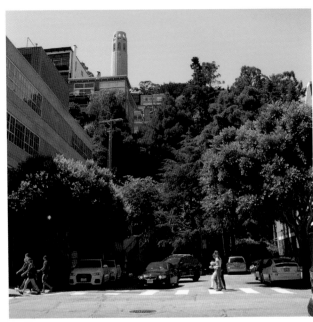

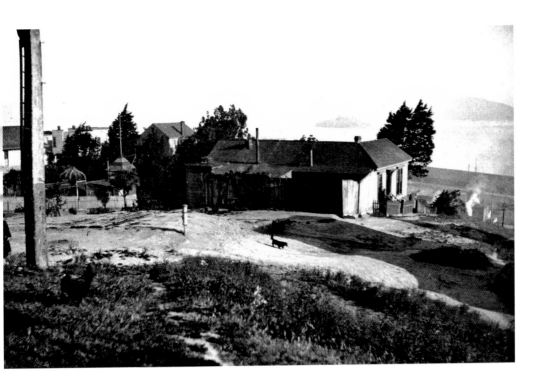

TELEGRAPH HILL CHICKEN
& DOGS: Quaint is a word
to describe the charming
chicken and dogs in the
foreground. Spectacular
is the setting behind this
ramshackle wooden cottage
situated at the edge of
Telegraph Hill. This image is
of an early settlement on the
east side of Telegraph Hill
in the 1890s. We are looking
north, past Meiggs' Wharf,
towards the Marin headlands.
Alcatraz Island is at the
top center. Cottages have
been replaced with upscale
residences and apartments
within what is called the
North Beach District.
[T: JBM] [B: CA]

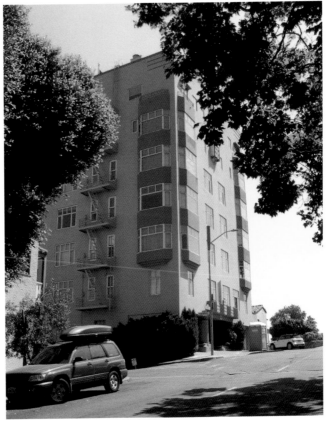

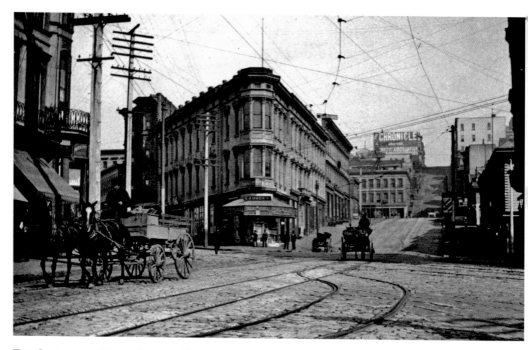

THE GATEWAY TO NORTH BEACH - COLUMBUS, KEARNY & MONTGOMERY STREETS: At the beginning of the twentieth century, this intersection was known as the "Gateway to North Beach." Ravaged by the 1906 fire, a number of structures were destroyed and later rebuilt. A left turn would take one up into the heart of North Beach. Hotels and rooming houses occupied the top floors of these buildings while businesses occupied the street level, and so it remains at the time of writing. [T: JBM] [B: CA]

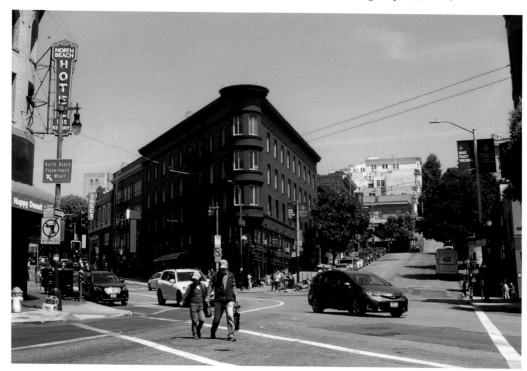

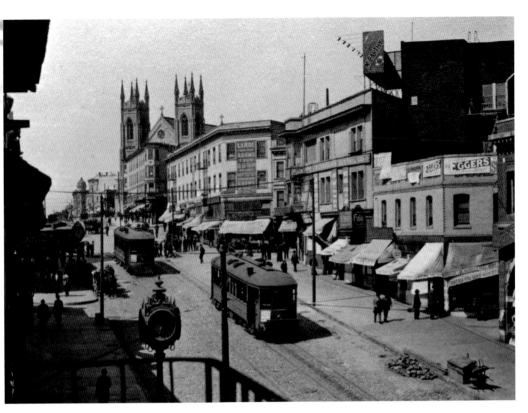

COLUMBUS AVENUE WITH STREET CAR: Built in the 1870s, the thoroughfare was originally called Montgomery Avenue, connecting downtown with the waterfront. In 1909, the name of Montgomery Avenue was changed to Columbus Avenue in honor of Christopher Columbus. [T: JBM] [B: CA]

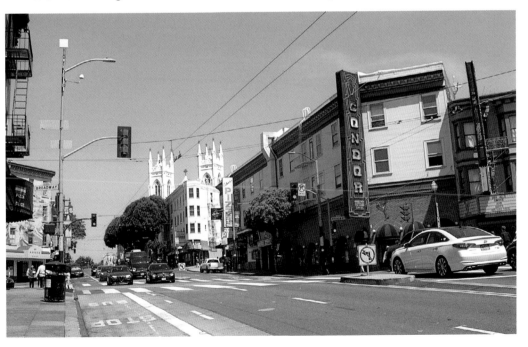

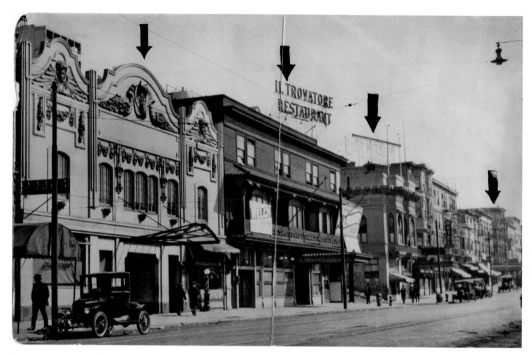

IL TROVATORE RESTAURANT: The restaurant, as it looked the early 1900s, was located at 504 Broadway, owned by Archimedi Puccinelli, an early Italian pioneer. He arrived in San Francisco from Lucca, Italy, at age eleven. Historians report that there were 1,621 Italians in San Francisco in the late 1800s. The building still stands, and the lower level is the site of a restaurant. [T: SFPL] [B: CA]

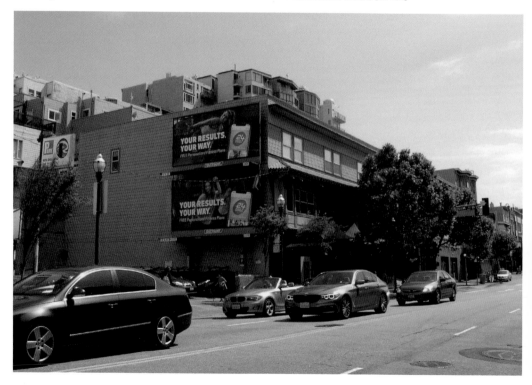

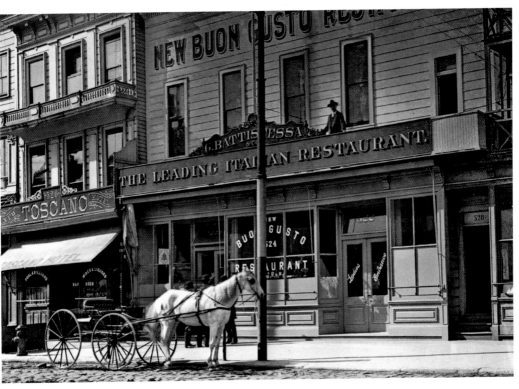

BUON GUSTO RESTAURANT: This was one of the leading Italian restaurants in San Francisco's North Beach District during the late nineteenth century, located at 524 Broadway on what was then a bustling thoroughfare in Little Italy's North Beach District. As with many delicious memories of Little Italy, it is now gone. The site is currently a parking lot. [T: JBM] [B: CA]

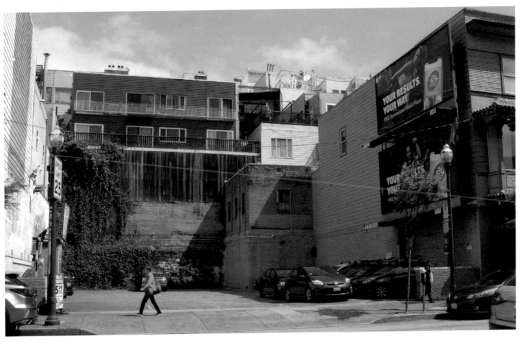

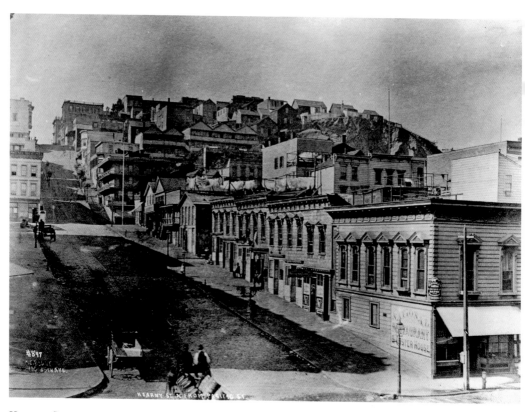

KEARNY STREET FROM PACIFIC STREET: Now we are looking up at the Kearny Street towards the Kearny steps as they looked in the late 1890s and today. In the North Beach District, over many decades, the steep incline of Telegraph Hill continues to stand ready to challenge the adventurous walker. [T: SFPL] [B: CA]

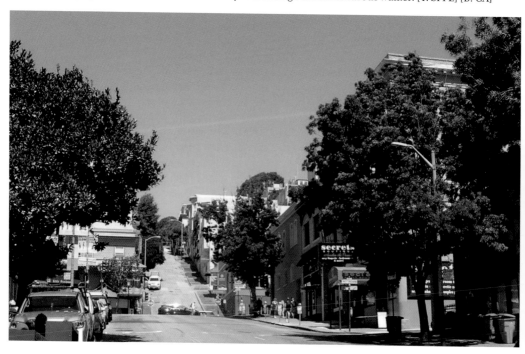

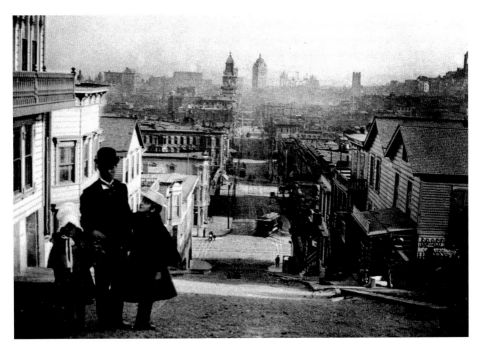

KEARNY STREET STEPS: Looking south down these famous steps a few days before the 1906 earthquake, we enjoy a family scene in the foreground with the bustling metropolis in the background—a scene that is now considered a rare glimpse indeed into the then tranquil life on Telegraph Hill. Today, the well-worn steps still exist and the deceptively worn ambiance is actually quite expensive, suggesting an entirely different urban fabric. [T: JBM] [B: CA]

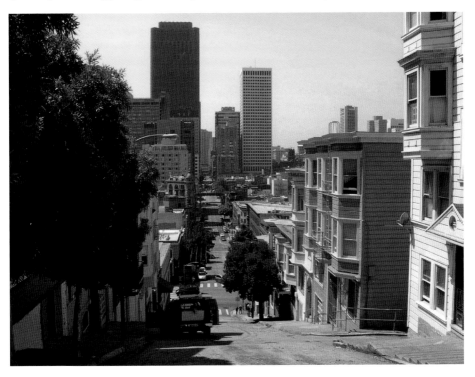

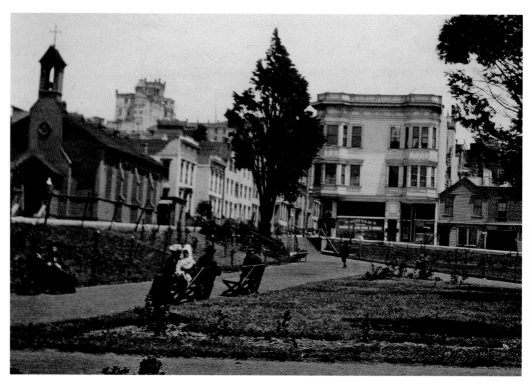

WASHINGTON SQUARE PARK: A peaceful day in North Beach's neighborhood park is depicted in this photograph. The city block, bounded by Stockton, Filbert, Columbus, and Union Streets, has served as a cow pasture, cemetery, and dumping ground. As one of the city's first three official parks during the mid-1850s, it is now beautifully restored and the pride of the neighborhood. [T: JBM] [B: CA]

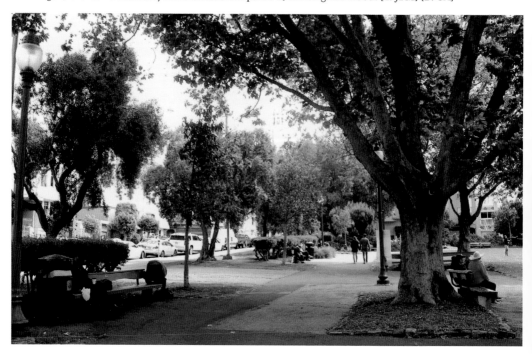

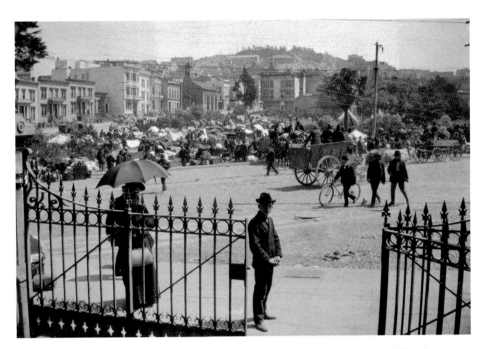

WASHINGTON SQUARE PARK WITH REFUGEES: After the 1906 earthquake and fire, the square served as home to 600 refugees. A registered San Francisco landmark, the designation reads, "As it has for well over a century, Washington Square continues to serve as a green oasis as well as a cultural focal point for San Francisco's lively North Beach. Its continuing natural condition makes it highly significant as an historic resource within a densely urbanized area." [T: JBM] [B: CA]

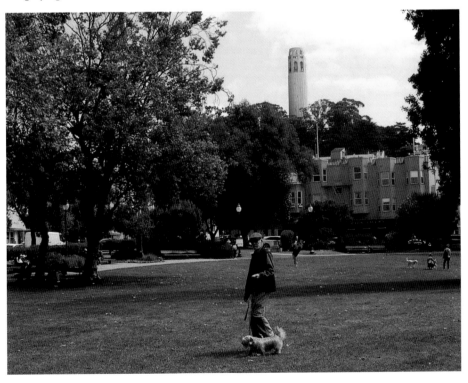

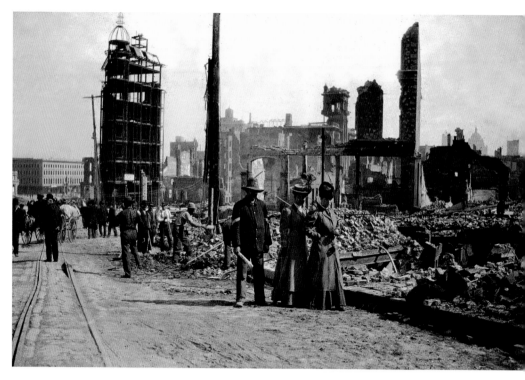

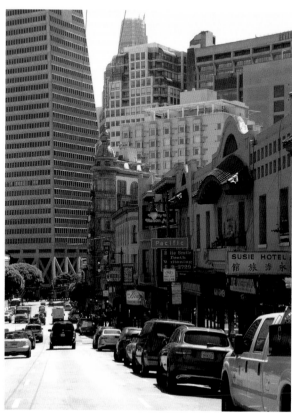

J. B. MONACO STUDIO: The Dean of North Beach photographers had a studio in the 200 block of Columbus Avenue where Monaco family members, Frank Giovanessi, Lydia Cavalli, and Nina Monaco, pose alongside the 1906 earthquake ruins of the family business. Monaco's photographic collection includes a body of work impressive in scope and content as he photographed the world around him, including this stunning image. The studio is gone, replaced by a variety of small shops. [T: JBM] [B: CA]

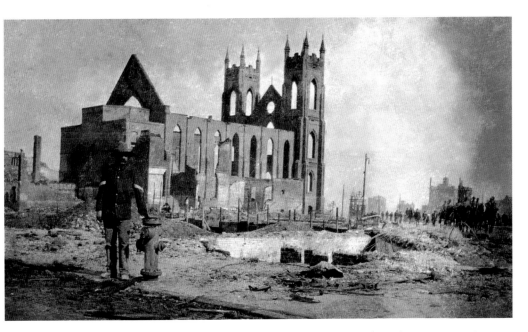

ST. FRANCIS CHURCH: Frank Giovanessi ironically stands next to a fire (water) hydrant with the ruins of Saint Francis Church in the background. Hydrants and cisterns that were available were too few and so the charred ruins of this landmark church loom in the background. Rebuilt using the original walls, it remains an important Catholic community church. [T: JBM] [B: CA]

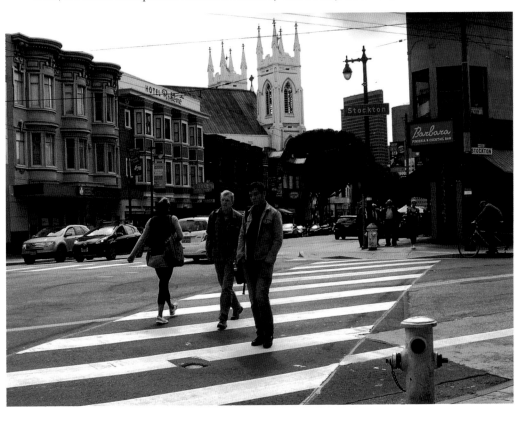

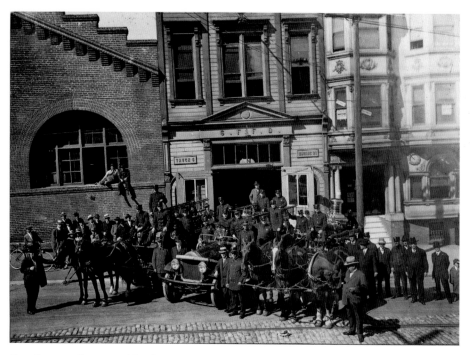

FIRE ENGINE COMPANY NO. 21: Firehouses like this one fought the 1906 conflagration. In 1893, Henrikson & Mahoney designed this Victorian-style firehouse at 1152 Oak Street. Retired from service after seventy years, it continued in use as storage and a gymnasium until being declared surplus in 2004, until area merchants and residents saved it from sale. It remains part of the neighborhood and San Francisco Landmark No. 89. [T: SFPL] [B: CA]

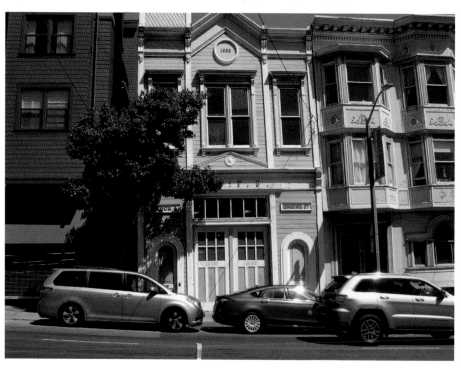

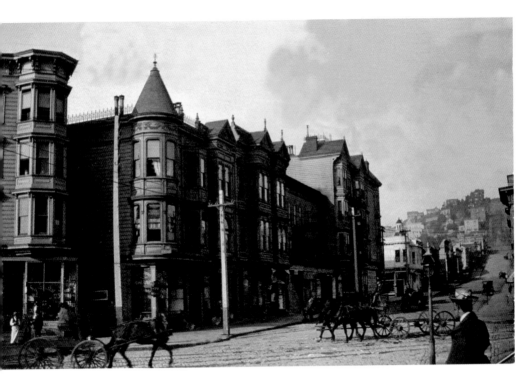

DANTE MONACO RESIDENCE: The corner of Columbus and Vallejo Streets has undergone quite a transformation. The structure in the center was the residence of Dante Monaco, son of famed North Beach photographer, J. B. Monaco. This was the time North Beach, Little Italy, was the center of Italian life. Years later, the site was occupied by Rossi Market and now is the location of Ace Hardware. [T: JBM] [B: CA]

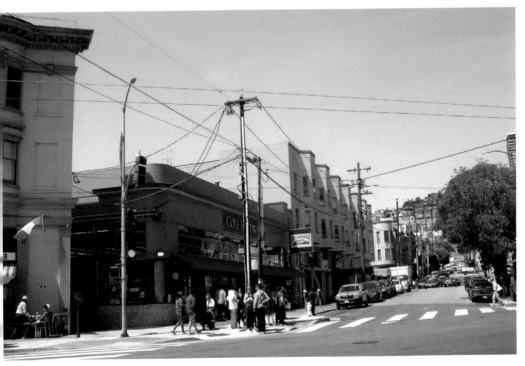

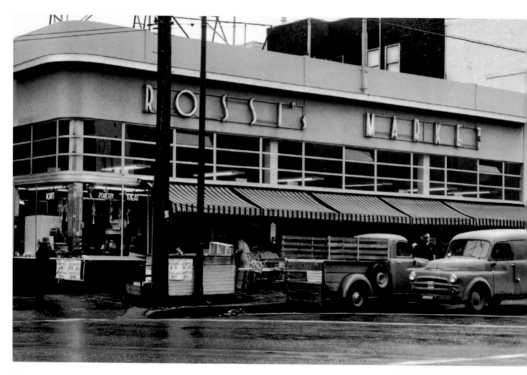

ROSSI MARKET: What would an Italian neighborhood be without great grocery stores like Rossi's Market at 627 Vallejo Street? Here it is on January 18, 1955. This was a full-service market providing fresh fruit, vegetables, and a butcher. This iconic business was eventually replaced by an Ace Hardware store. [T: SFPL] [B: CA]

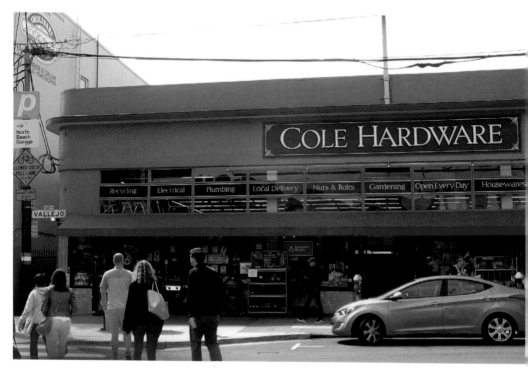

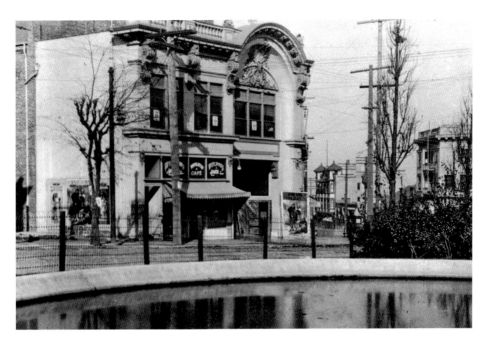

MILANO (PALACE) THEATER: The theatre opened on April 10, 1909, as the Washington Square Theatre, with 1,000 seats at five or ten cents per seat. The opening as an Italian theatre was a great event in the community. Operating as such until the 1930s, it was sold and renamed the Milano. It was extensively remodeled in the late 1930s in the moderne style and reopened as the Palace on November 5, 1937. Renamed the Pagoda in 1974, its last days as a film theatre were in December 1994. The theater was demolished in 2013 and replaced with condos. [T: BJM] [B: CA]

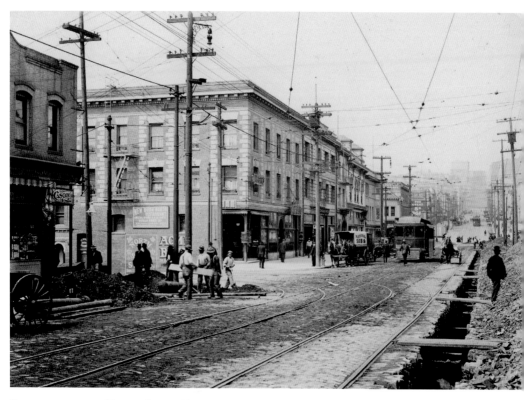

BROADWAY IN THE NORTH BEACH DISTRICT: Many streets of San Francisco boasted street cars back in the day. An important thoroughfare, Broadway, seen here *circa* 1910, was no exception. One thing does remain constant: ongoing street disruption due to construction. [T: SFPL] [B: CA]

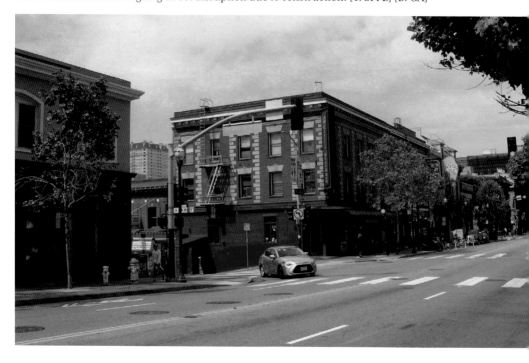

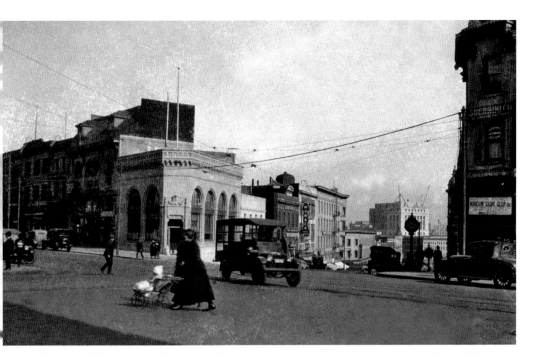

COLUMBUS & BROADWAY: For decades, the intersection of these two prominent streets formed the center of San Francisco's Little Italy. Here we see a day in the 1920s where Italian businesses anchored every corner and the streets were alive with activity. It remains a hub but with quite a different ambiance. [T: JBM] [B: CA]

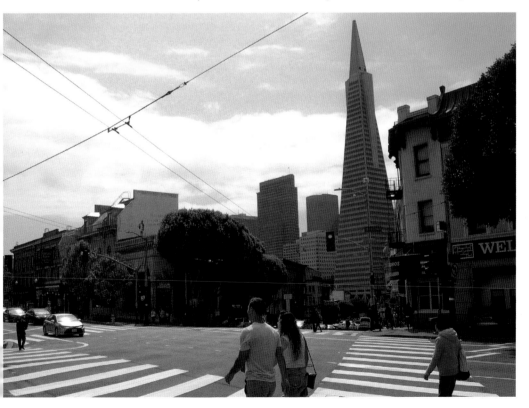

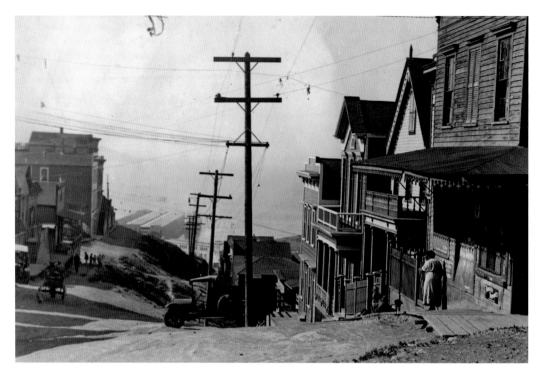

MONTGOMERY & UNION STREETS: This 1920 image captures a woman standing in front of Meisel's store. German immigrant Herman A. Meisel opened his store in 1881, selling groceries, sundries, and whisky. Years later, it became the Dead Fish Cafe run by Honore Gledhill. In the background is a glimpse the waterfront and San Francisco Bay. Now the street is lined with mature trees, endless vehicles, and pricey hilltop dwellings. [T: SFPL] [B: CA]

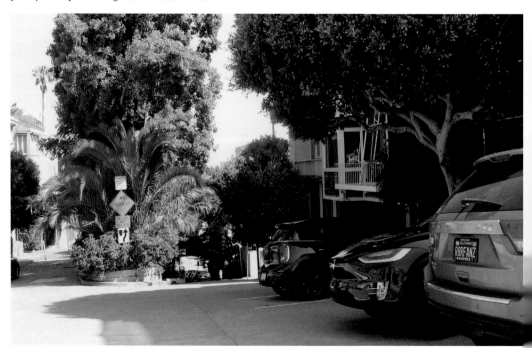

Telegraph Hill
Union Street View
(North Side):
Union Street on
The Hill looked like
this in 1940. Most of
these houses date
back to the 1800s. The
Department of Public
Works is upgrading
the street. At the end
of the street and to the
right is Pier 19 with
a large ship docked,
and in the distance,
we can see Treasure
Island complete with
the ongoing Golden
Gate International
Exposition. Happily,
not much has changed.
[T: LOC] [B: CA]

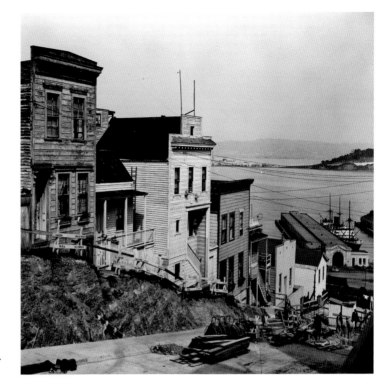

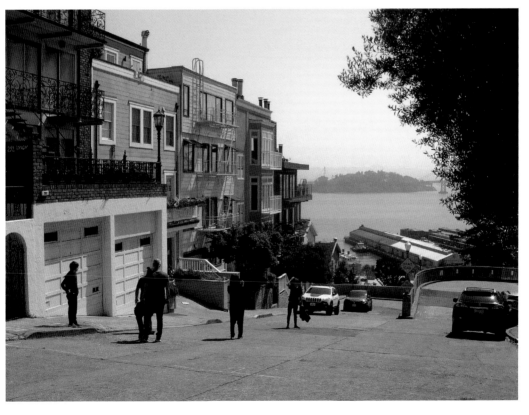

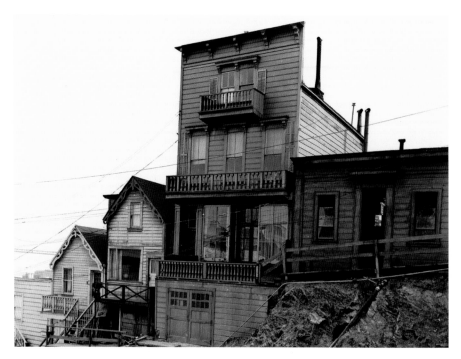

TELEGRAPH HILL UNION STREET VIEW (SOUTH SIDE): A charming view of three historic gems with the former Cooney home in the center at 291 Union, one of the oldest in San Francisco. Built in the mid-1800s by John Joseph Cooney, an Irish immigrant, it had a grocery store on the bottom level until 1906. The cottages adjacent were built *circa* 1857. Again, not much has changed, except for the costs of housing. One of the original wooden cottages recently sold for well over $1 million. [T: LOC] [B: CA]

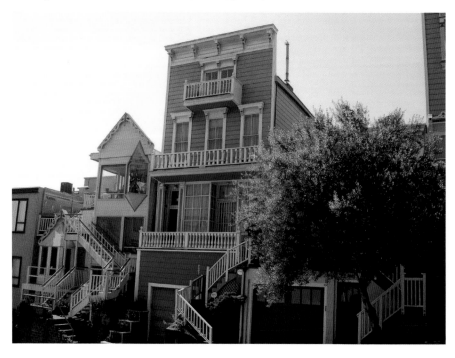

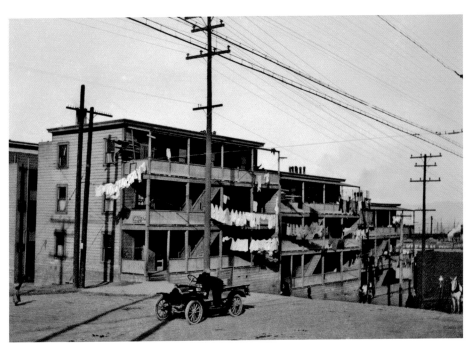

CUNEO FLATS: These typically San Francisco flats were located at Bay and Leavenworth Streets *circa* 1904. Joseph Cuneo was an important figure in the neighboring North Beach district. The caption for this photograph reads: "Rush hour traffic at Bay and Leavenworth Streets." Although an apartment building continues to occupy the site, many aspects of this location have changed in the past 100 years, including the traffic. [T: JBM] [B: CA]

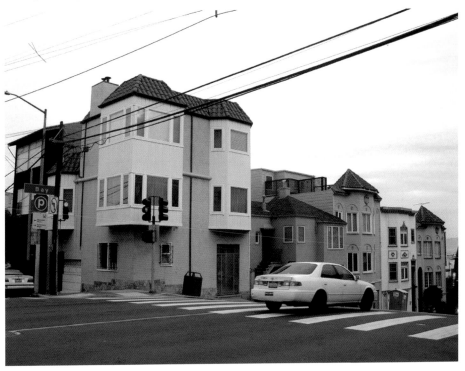

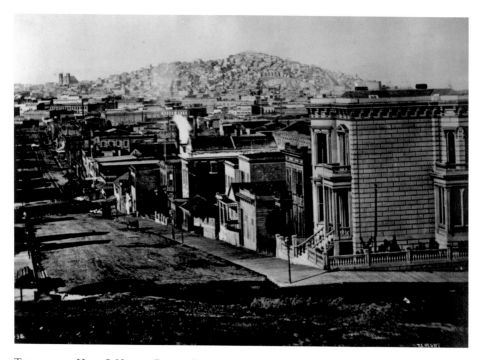

Telegraph Hill & North Beach District from First & Harrison Streets: Dramatic change over 150 years describes these views along First Street looking north through the central business district and beyond to the North Beach District nestled at the foot of Telegraph Hill. The once residential neighborhood of modest dwellings is now a street lined with concrete and steel. [T: SFPL] [B: CA]

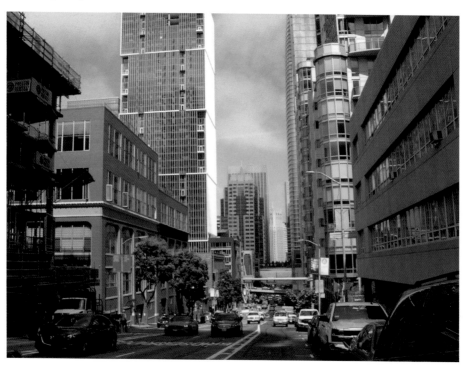

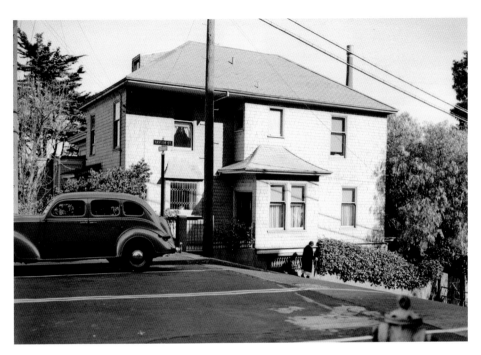

HOUSE OF THE FLAG: Telegraph Hill is not the only hill in town. On Russian Hill there is a survivor of the 1906 disaster, the 1850 landmark Sheppard-Dankin house at 1652-1656 Vallejo Street. Owned by retired U.S. diplomat, Eli Sheppard, and later by flag collector, Edward A. Dankin, it is known for being dramatically rescued from the 1906 fire when Dakin raised the American flag beside the house as the fire approached. Impressed, a company of soldiers were inspired to charge up the hill to fight the fire. They found sand and a bathtub full of water to douse the flames. Since then, it has been referred to as the House of the Flag. [T: LOC] [B: CA]

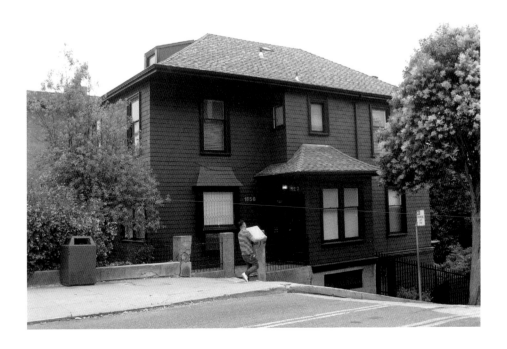

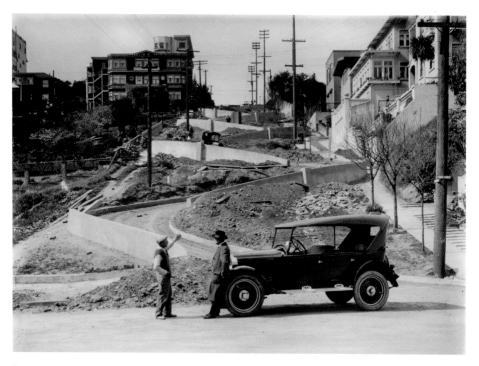

LOMBARD STREET: Running through Russian Hill, the crooked portion of the street was designed in 1922, after it was determined that the 27% grade was too steep for vehicles and switchbacks were designed to increase safety. Interestingly, the name Lombard has no link to San Francisco history but rather is named after a street in Philadelphia. Although often referred to as the "Crookedest Street in the World," it is not, and not even the crookest in San Francisco. Vermont Street in the Potrero Hill neighborhood has that distinction. [T: SFPL] [B: CA]

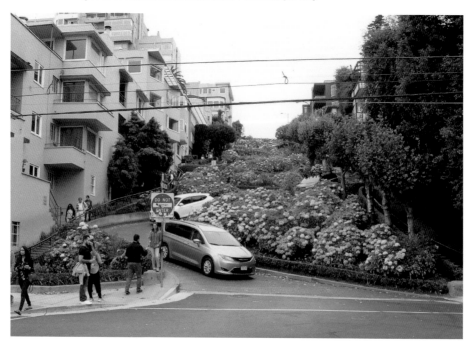

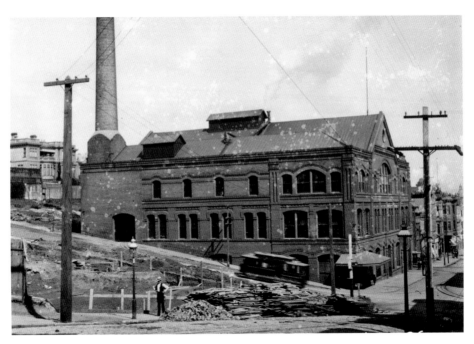

CABLE RAILWAY POWERHOUSE: A way up San Francisco's hills was the cable car. This barn and powerhouse is on the corner of Mason and Washington Street as it looked *circa* 1904 and present day. Inventor of the city's cable cars, Andrew Hallidie, was also instrumental in the design of the powerhouse. Since 1887, this is the place where power is sent to the system with four cables, 25 miles of metal, and 500-horsepower motors. The only surviving cable car barn and powerhouse in the city, there were fourteen at one time. It remains an active cable car facility and is San Francisco Landmark No. 43. [T: LOC] [B: CA]

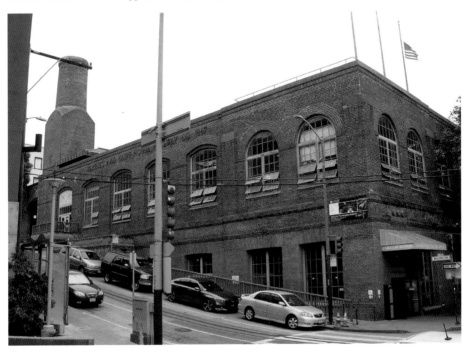

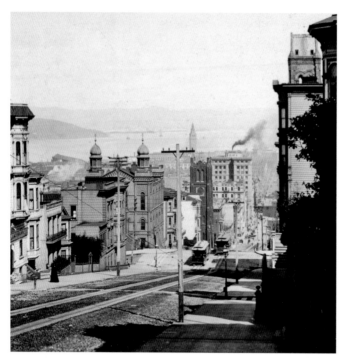

CALIFORNIA STREET—NOB HILL: California Street has its own cable car and has always been an important thoroughfare, so much so that, prior to the 1850s, Nob Hill was called California Hill. It was renamed after the Central Pacific Railroad's Big Four tycoons (Crocker, Huntington, Stanford, and Hopkins) built their mansions on this prominent location. They were known as the "nobs," a term for ostentatiously wealthy men. Some fifteen decades later, the street remains one of San Francisco's swankest addresses. [T: LOC] [B: CA]

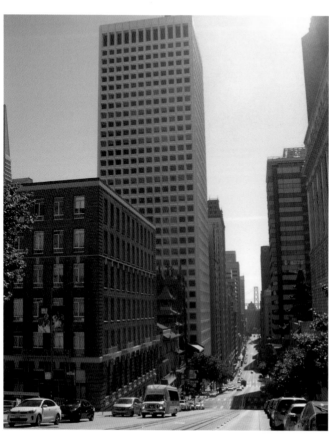

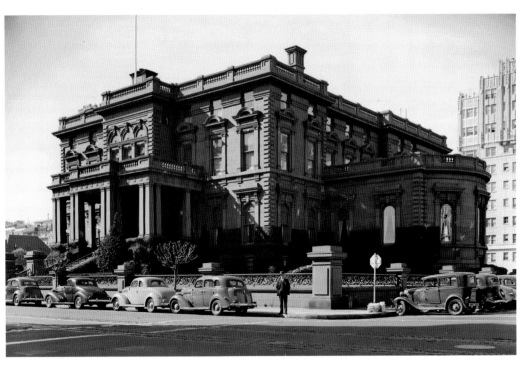

FLOOD MANSION: The mansion, at 1000 California Street, was the only residence on Nob Hill to survive the 1906 fire, saved by its brownstone walls. Built in 1886, designed by Augustus Laver, it was the residence of Nevada Comstock Lode tycoon, James Flood. The Pacific Union Club purchased the shell after the 1906 disaster, rebuilt, and it remains the home of the club and a National Register landmark. [T: LOC] [B: CA]

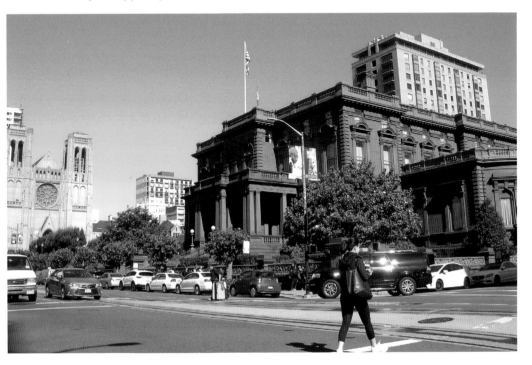

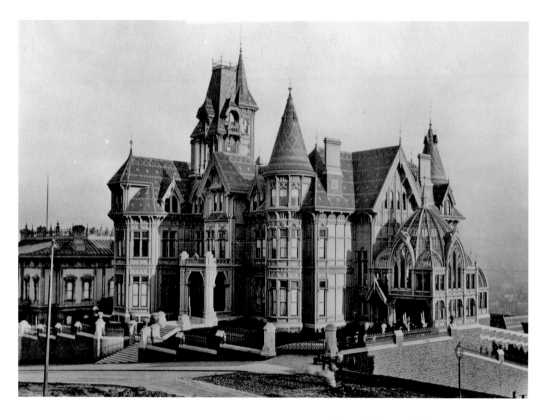

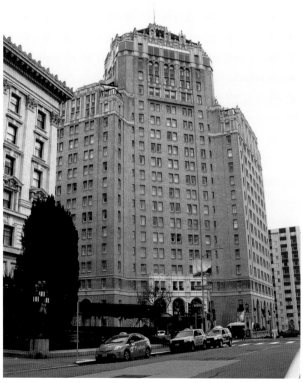

MARK HOPKINS HOTEL:
Designed by Weeks and Day in the Gothic Revival style in the 1920s, the hotel occupies the site of the Mark Hopkins mansion. In the late 1800s, the Mark Hopkins mansion on Nob Hill was home to the Mark Hopkins Institute of Art. Destroyed by fire in 1906, the school was rebuilt and renamed the San Francisco Institute of Art. In 1926, the school moved to its present location at 800 Chestnut Street and took the name, the San Francisco Art Institute.
[T: SFPL] [B: CA]

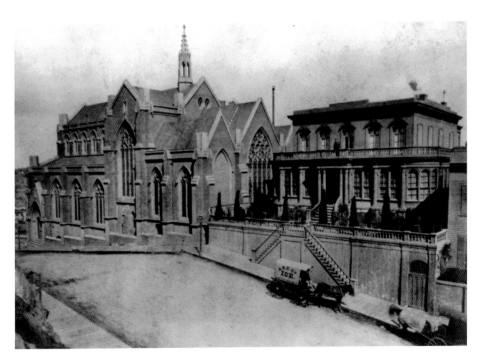

GRACE CATHEDRAL: This was, at the time, the third version of the church in 1862, an architecturally ambitious Gothic structure. It stood at California and Stockton Streets until it succumbed to fire in 1906. The rebuilt Grace Cathedral stands further up on Nob Hill while California and Stockton Streets is the site of the equally historic San Francisco landmark, the Metropolitan Life Building, now home to the Ritz Carlton Hotel. [T: LOC] [B: CA]

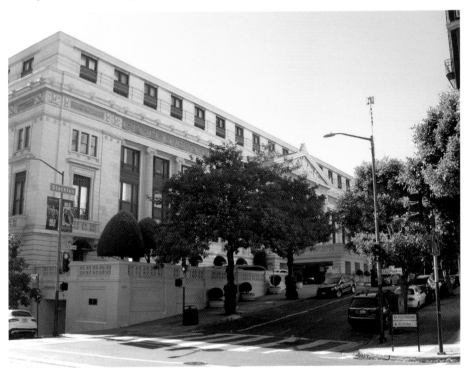

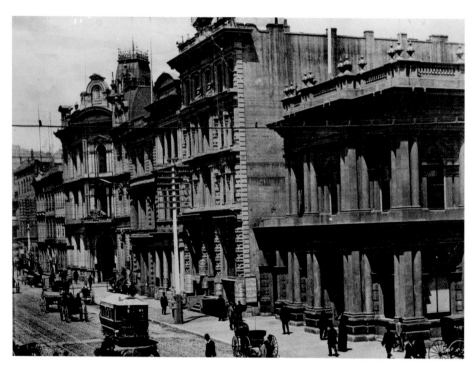

BANK OF CALIFORNIA: Further down California Street was the original Bank of California, located at 400 California Street, founded by Darius Ogden Mills and William Chapman Ralston in 1864. Demolished in 1906, the original structure was replaced by the version seen here designed by renowned architects Bliss & Faville as a three-story classical temple with a main banking room rising to the roof some fifty feet in height. Acquired as part of an adjacent high-rise project, the structure now houses offices and a roof top garden. It was the oldest incorporated commercial bank in California and is San Francisco Landmark No. 3. [T: LOC] [B: CA]

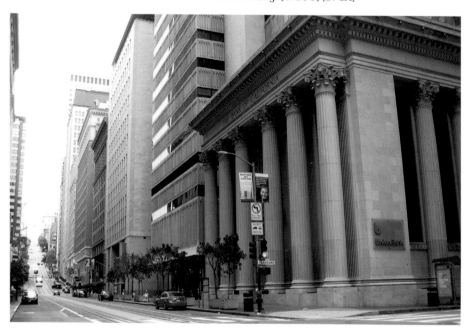

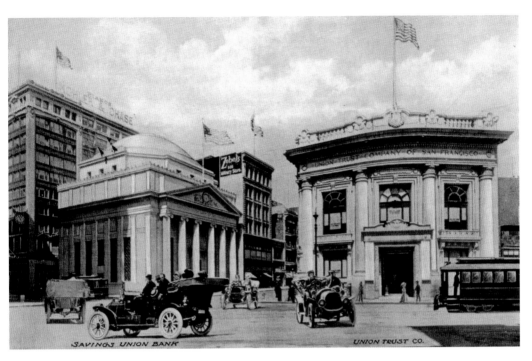

UNION TRUST BANK: This gorgeous San Francisco landmark graces 744 Market Street at Grant Avenue. It was built in 1910 by architect Clinton Day in a modified Classical Revival temple style. The building now houses a branch of Wells Fargo Bank. [T: SFPL] [B: CA]

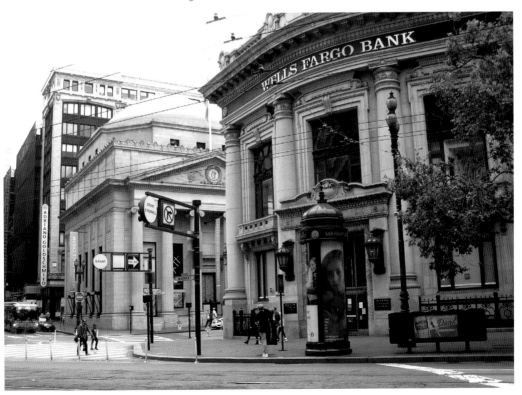

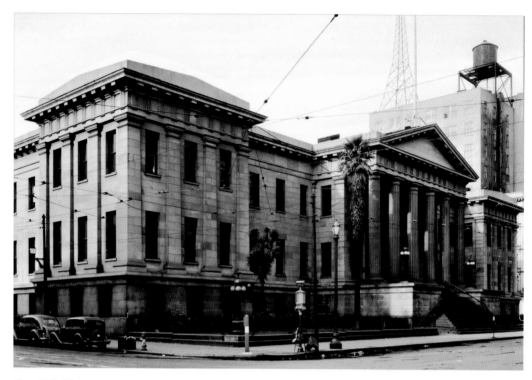

OLD U.S. MINT: This, the second San Francisco U.S. Mint, was constructed in 1869 and completed in 1874. It is a grand survivor of the 1906 disaster, saved by its iron shutters, 130-feet-high square brick chimneys, and brick masonry walls faced with Rocklin California granite base and blue-gray sandstone upper stories. In 1934, the San Francisco Mint housed one-third of the nation's gold reserve. This historic structure continues to serve the community as a museum and event venue. [T: LOC] [B: CA]

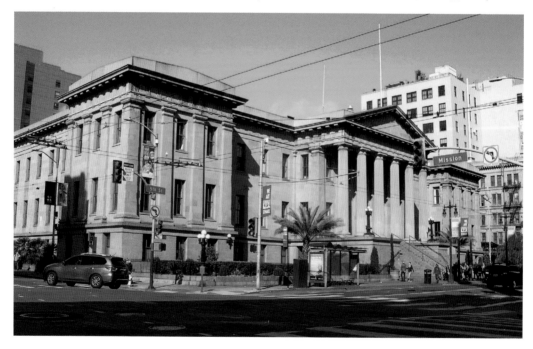

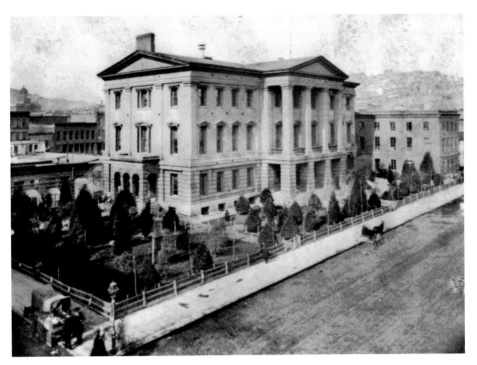

U.S. CUSTOM HOUSE: Since 1855, the earlier structure was located on Battery Street between Jackson and Montgomery Street. Demolished to make way for the newer building completed in 1911, it is an excellent example of the Beaux Arts Classicism style of architecture, which is characterized by classically exuberant details. The U.S. Custom House was listed on the National Register of Historic Places in 1975.

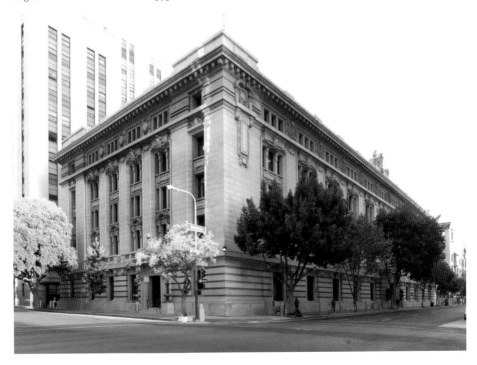

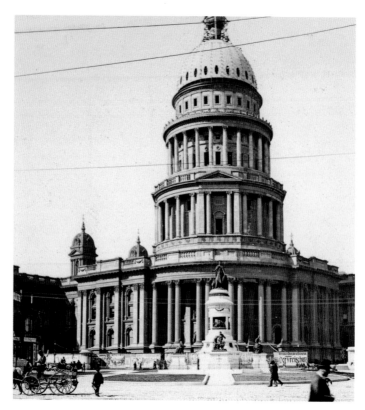

OLD CITY HALL: This third version of San Francisco's City Hall was located on Larkin Street near Grove Street at the approximate location of the original public library. Designed by Augustus Laver and Thomas Stent and completed in 1899, it took some twenty-seven years to build, but only minutes to destroy during the 1906 earthquake. The current City Hall was built just a few blocks away on Polk Street. The Pioneer Monument was actually moved one block in 1991 and placed in the middle of Fulton Street, where it currently stands. [T: LOC] [B: CA]

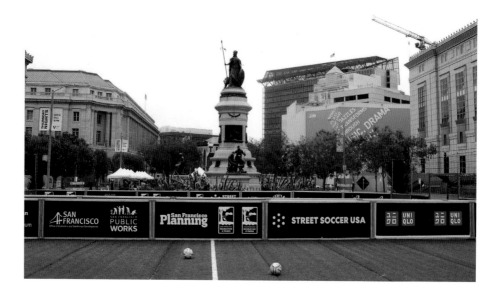

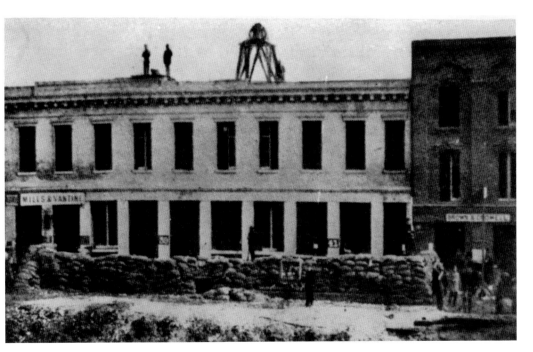

SACRAMENTO BLOCK/FORT GUNNYBAGS: The "Fort" was not really a government building, but a structure built in the 1850s as a warehouse. In 1856, the San Francisco Vigilance Committee made it their headquarters and arsenal and fortified it with gunnysacks, thus the name change to Fort Gunnybags. It was a simple, two-story Classical Revival building built of brick and stucco. It was located at 243 Sacramento Street near Battery, but now only a plaque on the side of an office building identifies the site. [T: LOC] [B: CA]

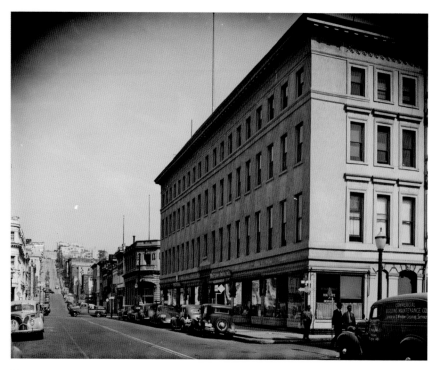

MONTGOMERY BLOCK: Before being demolished in 1959 and eventually replaced by the Transamerica Pyramid, it stood at 600 Montgomery Street. Conceived by Henry Wager Halleck and English trained architect Gordon Parker Cummings, it was considered fireproof and the safest and largest office building of its time. It became the favorite office space of professional men from 1853 and 1890, housing the Adolph Sutro Library and the domicile of artists and writers such as George Sterling, Maynard Dixon, and Jack London. [T: LOC] [B: CA]

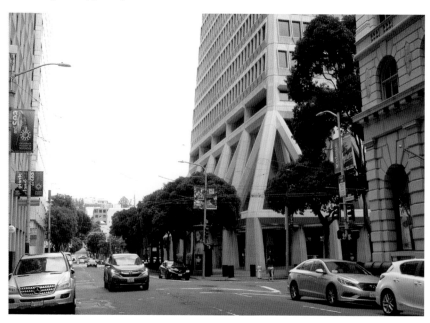

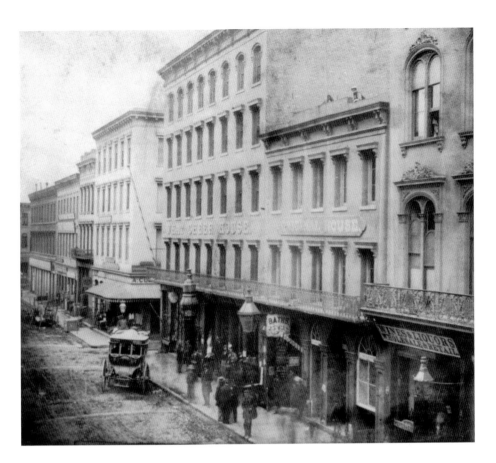

WHAT CHEER HOUSE: In 1852, Robert B. Woodward established the famous What Cheer House, located at the southwest corner of Sacramento and Leidesdorff Streets, before it was destroyed by the 1906 fire. The What Cheer House catered to men only, permitted no liquor on the premises, and housed San Francisco's first free library and first museum. A plaque on the side of a Wells Fargo building marks the site. [T: LOC] [B: CA]

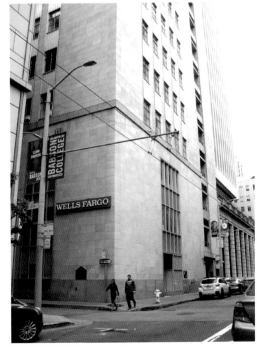

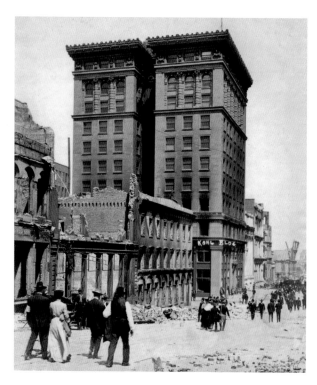

ALVINZA HAYWARD BUILDING
(AKA KOHL BUILDING): Designed
in 1901 by George Percy and Willis
Polk for wealthy businessman,
Alvinza Hayward, the building at
400 Montgomery Street was one
of the first steel-frame "fireproof"
buildings in San Francisco. Lower
stories have been redesigned,
but the upper stories with their
brick curtain walls clad in Colusa
limestone remain unchanged.
[T: SFPL] [B: CA]

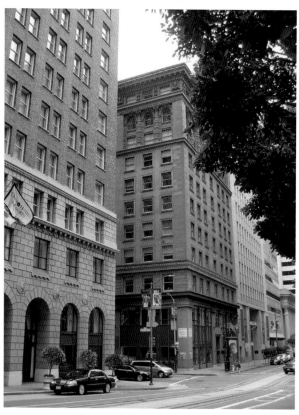

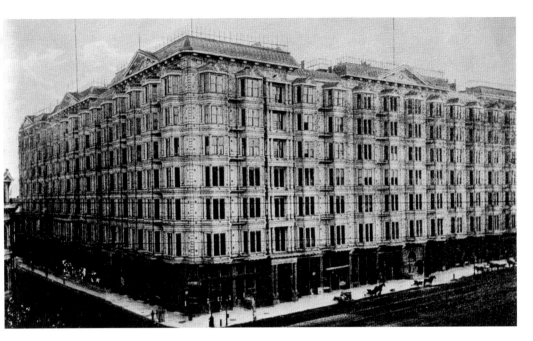

PALACE HOTEL: What a stunner! The original hotel, built in 1875 with 800 rooms, was San Francisco's first premier luxury hotel and the largest in the world. A new hotel was built after the 1906 disaster, undergoing award winning restorations in 1989 and 2015. It remains a stunning example of San Francisco's gilded age. [T: LOC] [B: LOC/CHA]

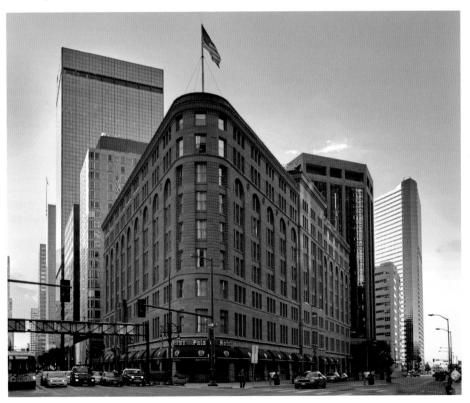

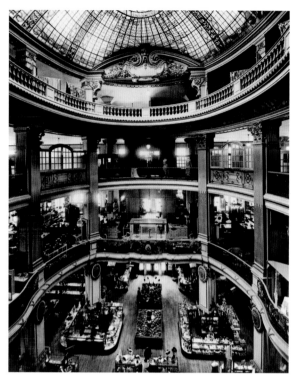

PALACE HOTEL GARDEN COURT: Although the grand Palace Hotel is not a designated landmark, the hotel's historic Garden Court is San Francisco Landmark No. 18. When the hotel was constructed, the area of the court served as an entry for horse-drawn carriages. Several years before the earthquake and fire, the Grand Court entry was redesigned into the Palm Court. Diners continue to enjoy elegant meals under a grand canopy of stained glass. [T: LOC] [B: LOC/CHA]

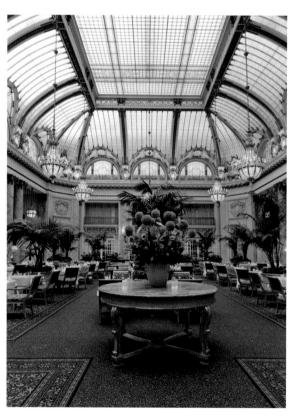

BALDWIN HOTEL: The luxury hotel and theater were located on Powell Street at the corner of Market Street. Built in 1875 by Comstock Lode millionaire, entrepreneur and gambler, Elias Jackson "Lucky" Baldwin, the hotel was designed by architect Sumner Bugbee in the Second Empire style. The structure occupied the entire block until destroyed by fire in 1898. Currently, the site is home to the Flood Building, built in 1904, and San Francisco Landmark No. 154. [T: SFPL] [B: CA]

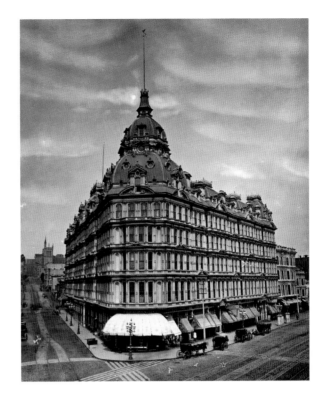

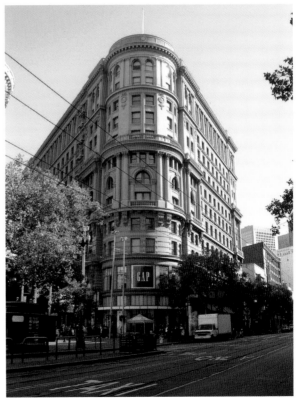

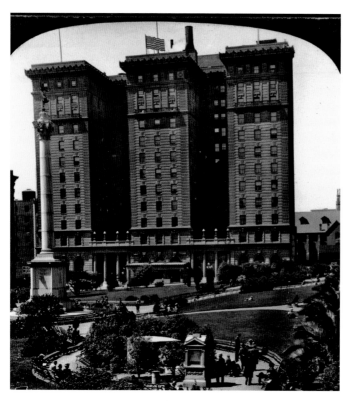

UNION SQUARE &
THE ST. FRANCIS HOTEL:
In the 1850s, the square was
a sandhill, undeveloped
for years. During the Civil
War, it took on its present
name because of several
pro-Union rallies held
there. In the late 1870s,
the square was formally
designed, with a park with
intersecting pathways and
plantings. At the turn of
the century, the square
underwent a major design
change, which included
erection of the Commodore
Dewey monument dedicated
by President Roosevelt
in 1903. The majestic St.
Francis Hotel was built in
1904, and both square and
hotel rebuilt after the 1906
disaster. After decades and
numerous redesigns, they
both remain the center
of San Francisco's chic
shopping district. [T: LOC]
[B: LOC/CHA]

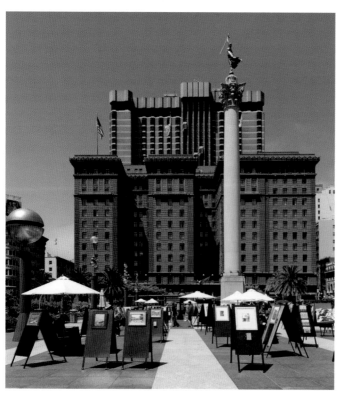

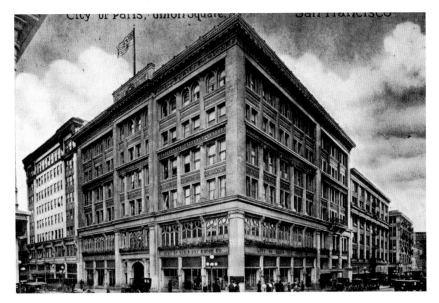

CITY OF PARIS DEPARTMENT STORE: In 1850, the Verdier brothers, immigrants from France, opened a store aboard the ship *La Ville de Paris* to serve the Argonauts passing through San Francisco's harbor. In 1896, the business moved into a new building across from Union Square designed by architect Clinton Day. Damaged by the 1906 earthquake, its interior was reconstructed by architects John Bakewell and Arthur J. Brown. The old City of Paris building was one of the finest examples of the beaux-arts style of commercial building in California, anchoring the corner of Geary and Stockton Streets until demolished in 1981 to be replaced by a Neiman Marcus store, saving only the interior rotunda. [T: LOC] [B: CA]

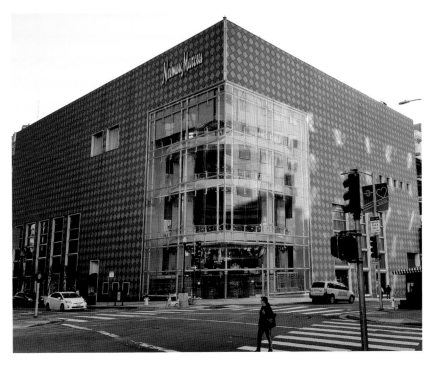

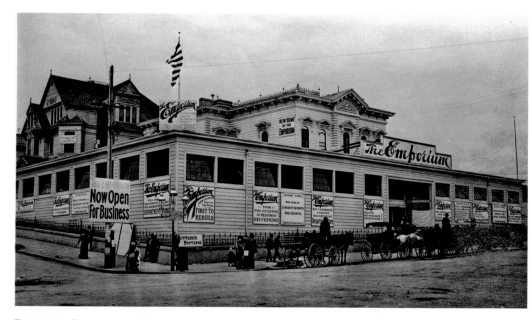

EMPORIUM DEPARTMENT STORE: After the 1906 disaster, the Market Street department store relocated to temporary quarters here at Post and Van Ness Streets. Although the Market Street structure was all but destroyed the business kept selling wares within ten days of the fire. Two signs on the facade read: "First to Rebuild" and "Took the Initiative in Restoring San Francisco." Below we have the location over 100 years later as the site of a sleek office building. [T: SFPL] [B: CA]

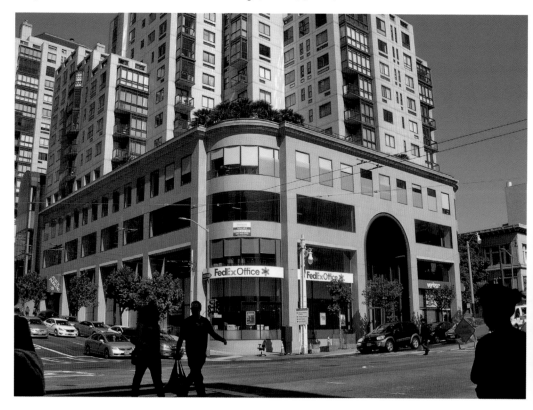

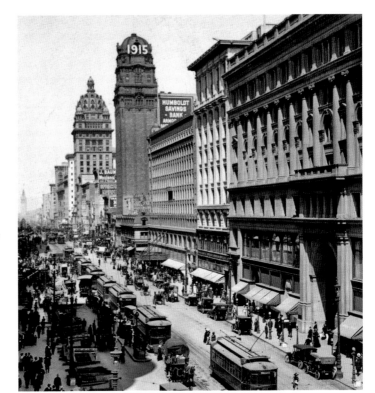

MARKET STREET:
The street was laid out by Jasper O'Farrell in 1847 and traverses the city from Twin Peaks to the Embarcadero. From the earliest days, pictured above *circa* 1915, it was, and still is, a main artery of the city's business and shopping districts.
[T: LOC] [B: LOC/CHA]

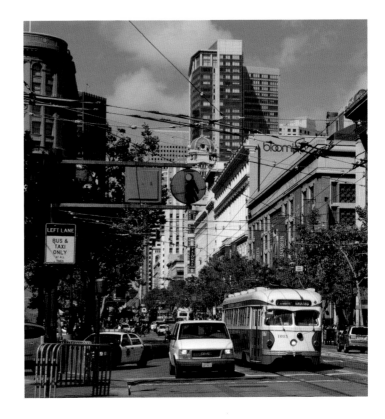

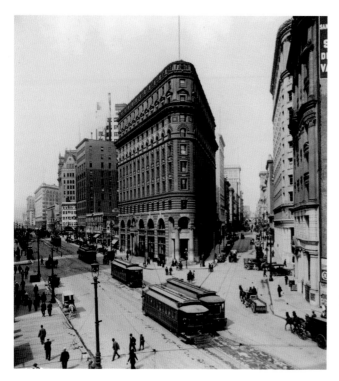

MARKET, MONTGOMERY & POST STREETS: In the center was the Crocker Building, erected in 1891 at a cost of $1,000,000 at eleven stories high. The ground floor was occupied by the Crocker-Woolworth National Bank and Shreve & Company jewelers. The upper floors were divided into offices until damaged by the 1906 disaster and later demolished. The site is now home to McKessen Plaza. [T: LOC] [B: CA]

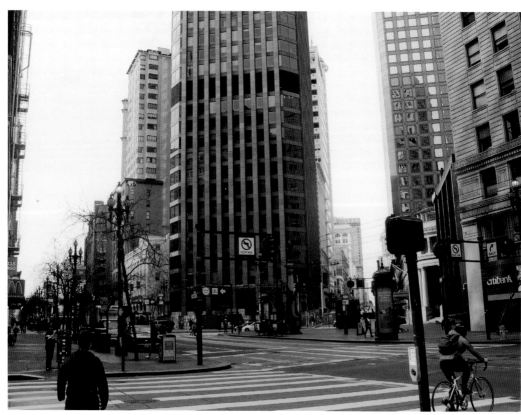

MARKET STREET
WELCOME ARCH: During
the late 1800s and early
1900s, Market Street was
adorned by several arches
at different times for
different occasions. An
article in the July 8, 1897,
San Francisco Call newspaper
describes this one as "The
Arch of Welcome" for the
Sixteenth International
Christian Endeavor
Convention.
[T: LOC] [B: CA]

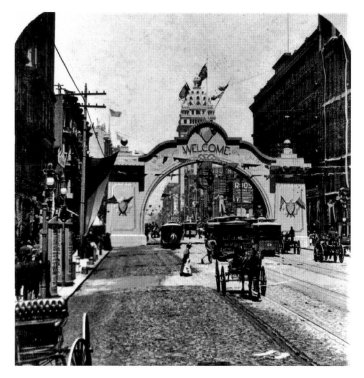

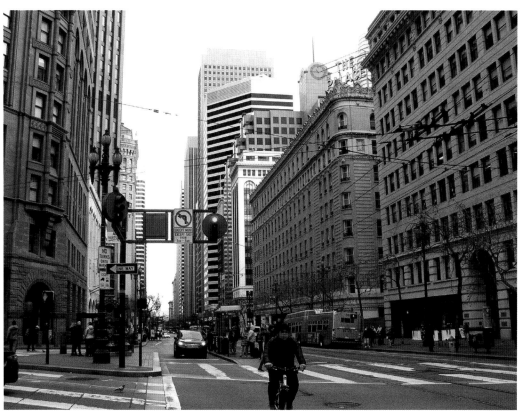

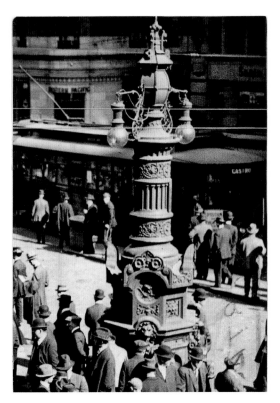

LOTTA'S FOUNTAIN: At the corner of Market, Geary, and Kearny Streets, it is a twenty-four-foot cast-iron sculpture. The fountain was commissioned by actress Lotta Crabtree in 1875 as a gift to the City of San Francisco, and would serve as the meeting point to commemorate 1906 earthquake survivors annually on April 18th. On Christmas Eve in 1910, Lotta's Fountain was engulfed by a crowd, estimated at 250,000 people, who had gathered to hear a performance by Madame Tetrazzini. It remains intact as a registered city and national landmark. [T: SFPL] [B: LOC/CHA]

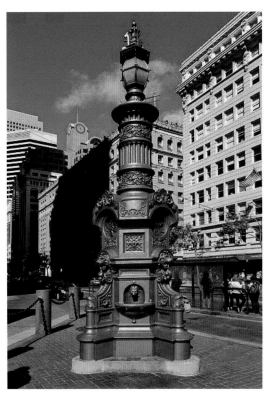

FOX THEATER: Market Street was the site of this stunning movie palace built in 1929 by movie pioneer William Fox as a showcase for the films of the Fox Film Corporation. The Fox Theatre opened on June 28, 1929, with the premiere of the Charlie Chan film, *Behind That Curtain*. Sadly, a decline in attendance began in the 1950s and on February 16, 1963, the theater closed. The theater was demolished in July 1963 and is now the site of the Fox Plaza, a high-rise apartment and office building. [T: SFPL] [B: CA]

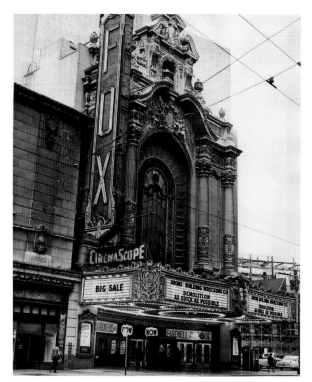

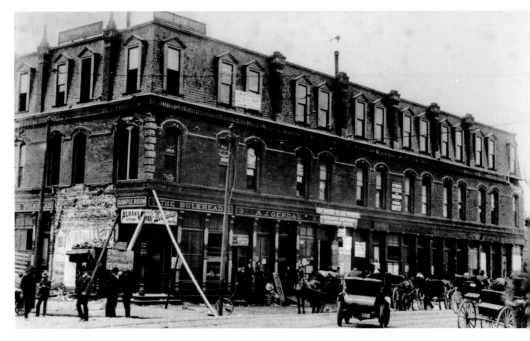

AUDIFFRED BUILDING: In 1889, Frenchman Hipolyte d'Audiffred built this commercial waterfront building in Parisian style. Located one block away from Market Street at 1-21 Mission Street, it is one of the few structures in the area to survive the 1906 fire. The nautical ornament on the ground floor cornice is a reminder the bay once came right near the door. The saloon operated on the ground floor while upper floors contained rooms for sailors and space for artists and musicians. Eventually deteriorated, ravaged by fire, and scheduled for demolition, the structure was saved and restored as a San Francisco and National Register landmark. [T: LOC] [B: CA]

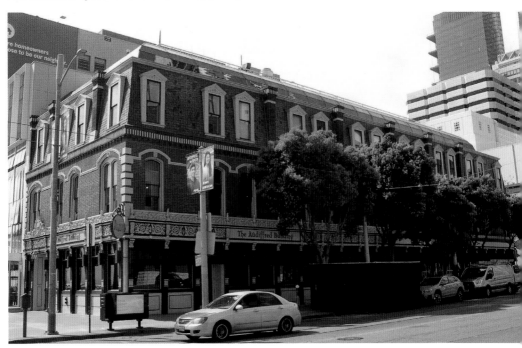

FERRY BUILDING: This structure has stood at the foot of Market Street as one of the city's most identifiable buildings since 1898. Originally named the Union Ferry Depot, the prominent 235-foot tower is visible for miles as the east side sign announces the Port of San Francisco. The clock faces were the largest in the United States at 22 feet in diameter, powered by a 900-pound weight. The Ferry Building remains intact and is a National Register landmark along the Embarcadero. [T: LOC] [B: CA]

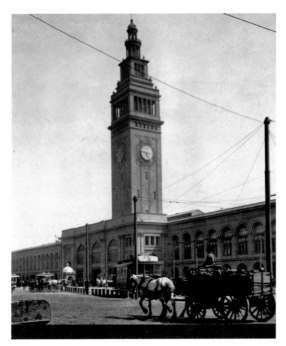

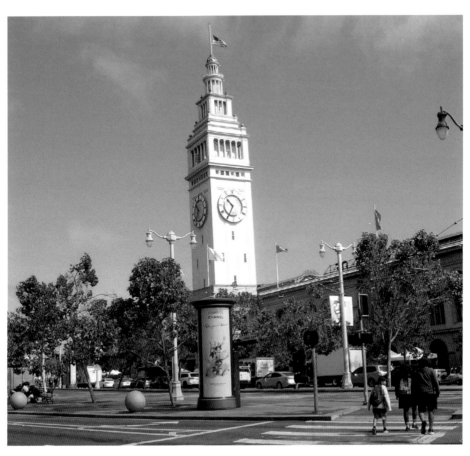

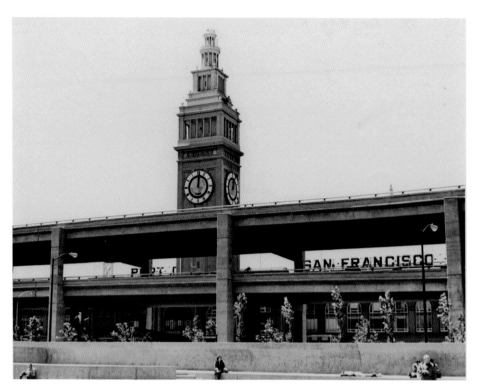

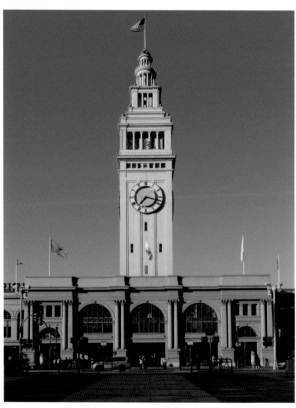

EMBARCADERO FREEWAY
& THE FERRY BUILDING:
Original plans for State
Highway Route 480 called for
several sections of freeway
dissecting San Francisco.
The first, the Embarcadero
Freeway, was built in 1959
extending from the Bay
Bridge approach to Broadway
Street on the Embarcadero.
Freeway opponents stopped
further construction but
the freeway remained until
damage from the 1989 Loma
Prieta earthquake closed
it to traffic. After years of
debate, demolition of the
much-lamented eyesore
began in 1991. [T: SFPL] [B:
LOC/CHA]

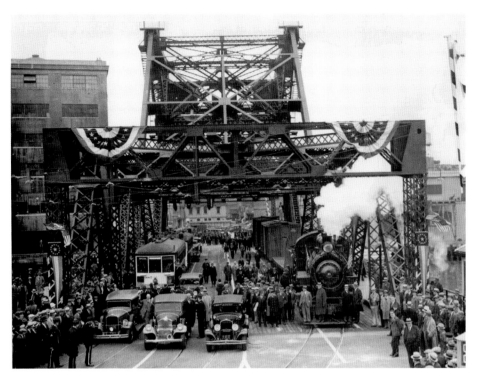

THIRD STREET BRIDGE: This 1933 bridge is San Francisco Landmark No. 194, rechristened Francis "Lefty" O'Doul Bridge in 1969. It traverses over the Mission Creek shipping channel consisting of a 143-foot steel truss, complete with electrically driven hoist machinery. It is still used today and has undergone an extensive rehabilitation project. [T: SFPL] [B: CA]

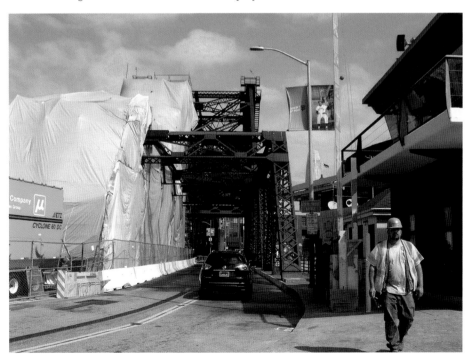

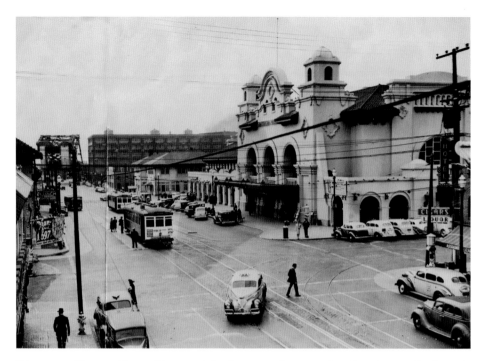

SOUTHERN PACIFIC TRAIN DEPOT: A fond memory for many San Franciscans, the Spanish revival style train depot was built to serve the 1915 Panama Pacific Exposition. Afterwards, it served commuter and freight trains for sixty years. Demolished in 1975, the site is now mixed-use buildings. A new station was built at Fourth and Townsend Streets. [T: SFPL] [B: CA]

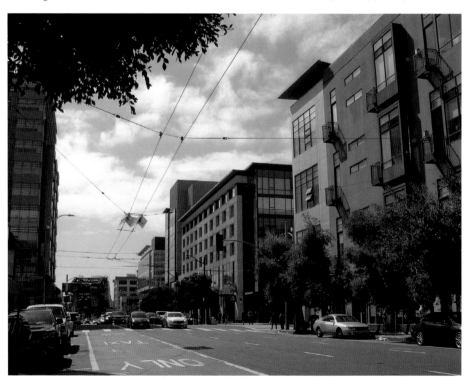

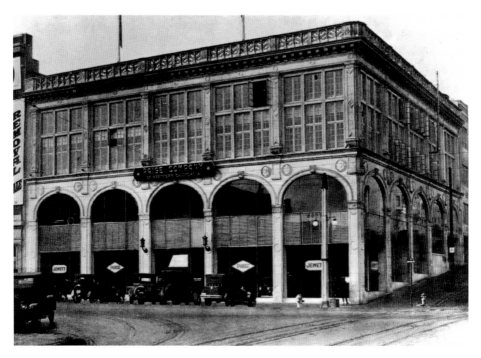

PAGE MOTOR COMPANY: Designed by Sylvain Schnaittacher, this building is one of the few remaining lavish motor car company buildings on the Van Ness Avenue's automobile row. These extravagant automobile showrooms were built during the mid and late 1910s. The Paige Motor Car building was built in 1912 at 1699 Van Ness Avenue. It now houses offices. [T: LOC] [B: CA]

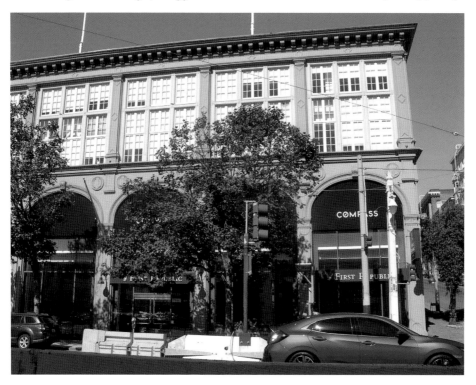

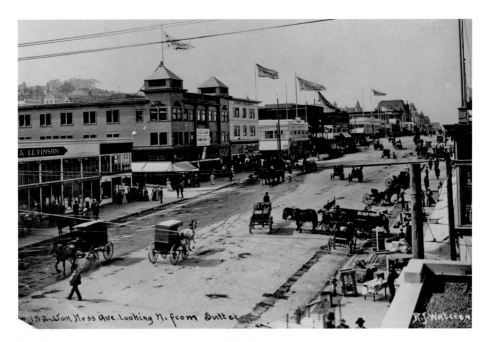

VAN NESS AVENUE: Van Ness Avenue is one of San Francisco's primary north-south transportation corridors. It was originally named Marlette Street, and renamed Van Ness Avenue in honor of the city's seventh mayor, James Van Ness. Serving as an important fire break in 1906, the avenue blossomed once again with a mix of lavish residences, commercial buildings, and even a rail line which was removed in the 1950s. At the time of writing, the avenue is again undergoing a massive improvement project. [T: SFPL] [B: CA]

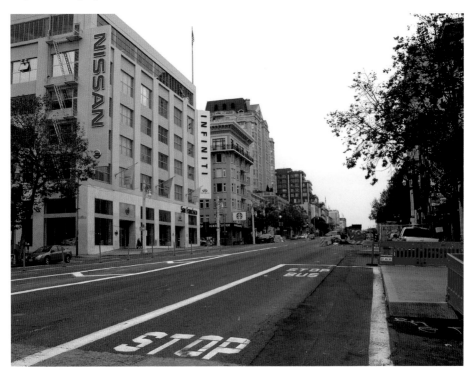

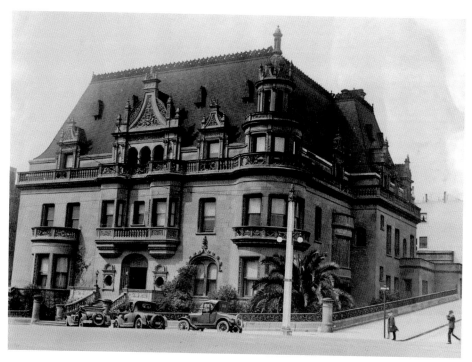

CLAUS SPRECKELS MANSION: In the late 1890s, one of Claus Spreckels' mansions was located at the corner of Van Ness Avenue and Clay Street at a time when the avenue was the location of numerous posh dwellings. It was one of the most expensive private California homes of its time. Its architecture was similar to many German hunting lodges and summer residences. Sadly, this magnificent structure succumbed to the 1906 fire, was rebuilt, and eventually destroyed in 1927. Now a relatively ornate apartment building occupies this prestigious corner. [T: SFPL][B: CA]

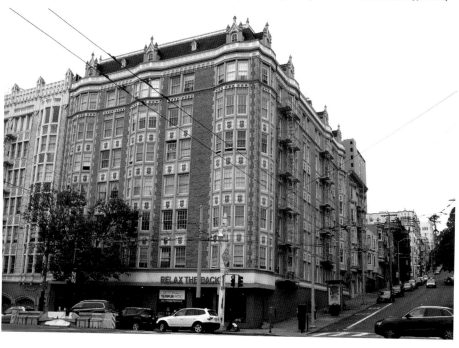

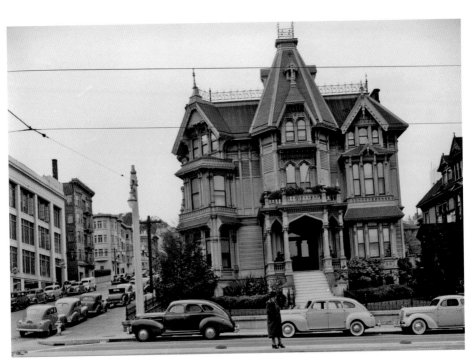

SILAS PALMER HOUSE: The Silas Palmer House was situated on the northwest corner of Van Ness and Washington Streets. Palmer was a prominent San Franciscan, engineer, contractor,and philanthropist. Built in 1886, the mansion was described by the Library of Congress as, "Essentially stick in style, with features of the Villa and Shingle eras, as well as tall Mansard roof. Squared bays are typical of 1880s. Destroyed after 1940." Sadly, after demolition, the site became a parking lot, and now, condominiums. [T: LOC] [B: CA]

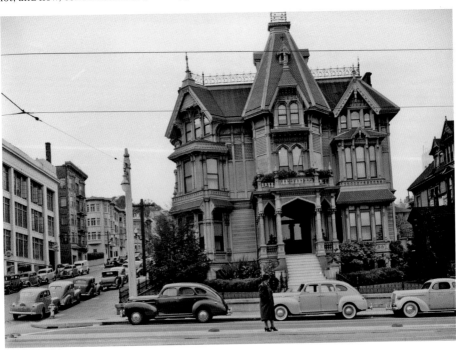

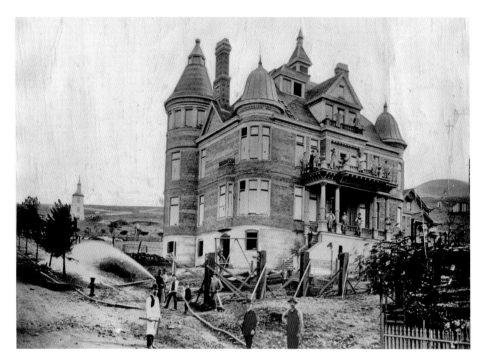

CLARKE MANSION: The mansion, built for attorney Alfred "Nobby" Clarke, was completed in 1891 at a cost of $100,000. Both Clarke and the mansion were notoriously eccentric and flamboyant and the edifice was quickly nicknamed "Clarke's Folly." In 1904, the structure was converted into the California General Hospital, survived the 1906 earthquake, and still stands as a residence at 250 Douglass Street, San Francisco Landmark No. 80. [T: SFPL] [B: CA]

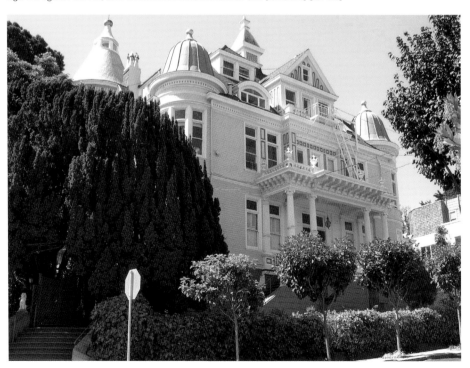

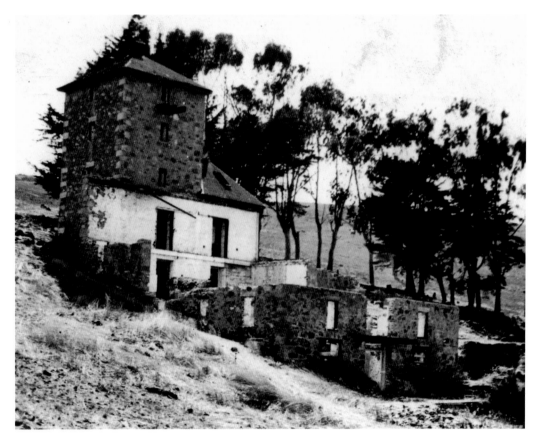

ALBION BREWERY: The brewery, also known as Albion Castle, located at 881 Innes Avenue, was founded in 1879 by John Hamlin. His building featured a three-story tower reminiscent of a Norman castle from his native England. It operated as a brewery using underground springs until 1919. Vacant and deteriorating, it was purchased and converted into a studio residence by sculptor Adrien Voisin. In 2012, a new owner commissioned an impressive renovation. The structure remains a private residence, designated San Francisco Landmark No. 60. [T: SFPL] [B: CA]

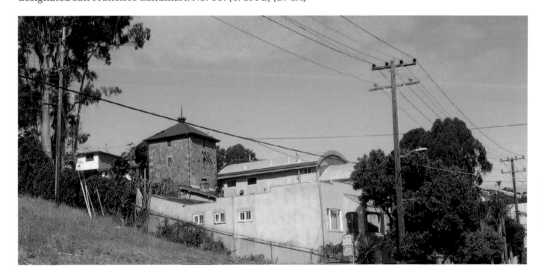

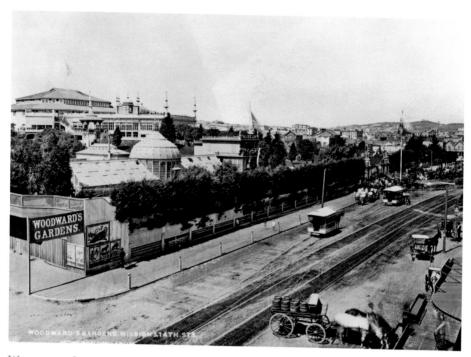

WOODWARD GARDENS: Recreation of all sorts was common in San Francisco. Robert B. Woodward opened his gardens to the public in 1866 as an amusement park catering to all tastes. It was San Francisco's most popular resort until it closed in 1892. Woodward's Gardens occupied the block bounded by Mission, Duboce, Valencia, and 14th Streets. A plaque now marks the site surrounded by freeways. [T: LOC] [B: CA]

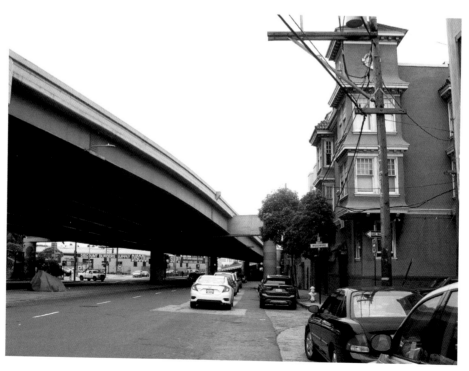

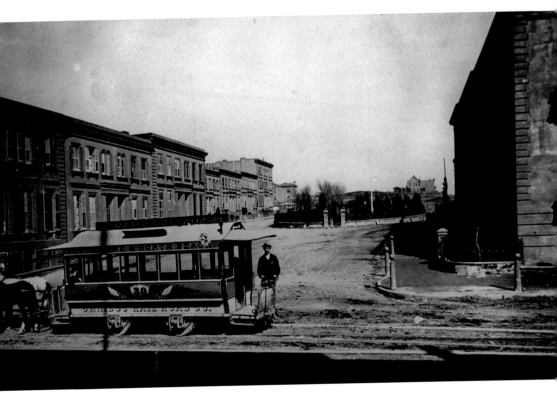

SOUTH PARK: Outdoor activities can be enjoyed in the City's numerous parks, including South Park. Constructed in 1855, it was conceived by British sugar and iron magnate George Gordon to resemble a square in London, England. The park was surrounded by fifty-eight swanky mansions on a 550-foot oval around a private park bounded by Second, Third, Bryant, and Brannan Streets. It featured a windmill and the first paved streets and sidewalks in San Francisco. It remains an urban park surrounded by quaint dwellings. [T: SFPL] [B: CA]

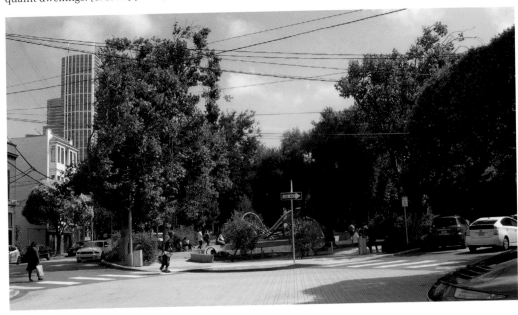

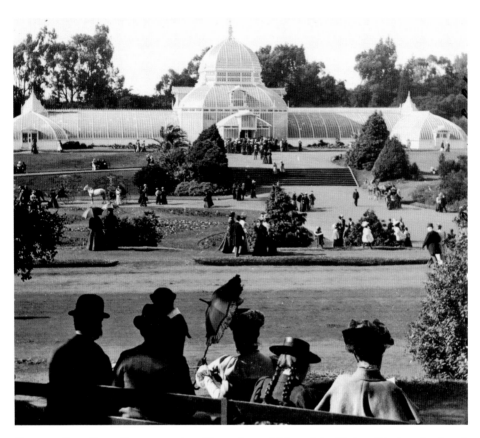

GOLDEN GATE PARK CONSERVATORY: The entirety of this park is a National Register landmark and the Golden Gate Park Historic District. The park contains thirty-seven contributing buildings, thirteen contributing structures, and thirty-six contributing objects. With an area of 10,170 acres, it is the largest urban park in the United States. The conservatory is often described as an "exquisitely anachronistic Victorian conservatory." Constructed between 1878 and 1879, it is one of the largest conservatories in the United States. [T: LOC] [B: LOC/CHA]

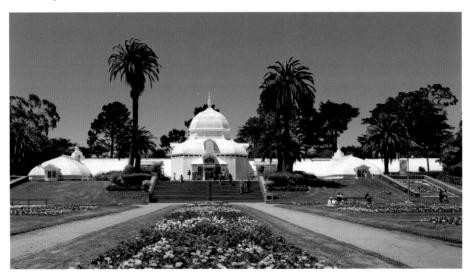

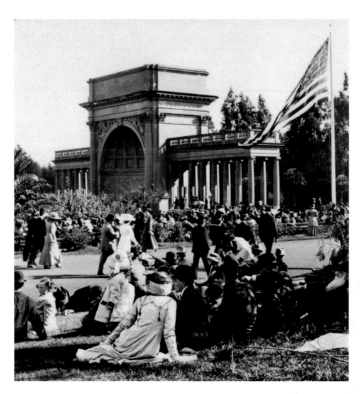

GOLDEN GATE PARK
MUSIC PAVILION:
Redevelopment of this
area after the 1894
Midwinter Fair resulted
in the creation of the
Music Concourse and de
Young Museum, which
now form the core of the
park's cultural center with
a bandshell, called the
Speckles Temple of Music,
also known as the Music
Pavilion, natural history
museum, art museum, and
the Japanese Tea Garden.
[T: LOC] [B: CA]

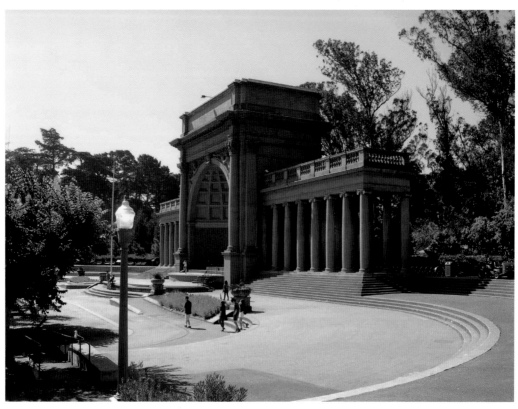

GOLDEN GATE PARK M. H. DE YOUNG MUSEUM: This fine arts museum opened in 1895 as an outcome of the 1894 California Midwinter International Exposition. Badly damaged in the 1906 earthquake, it was rebuilt under the guidance of Michael Henry de Young, founder of the *Daily Dramatic Chronicle* newspaper. The new structure was completed in 1919, opening in 1921. To accommodate a growing art collection and repair damage after the 1989 Loma Prieta earthquake, the museum was rebuilt and reopened in 2005. [T: LOC] [B: CA]

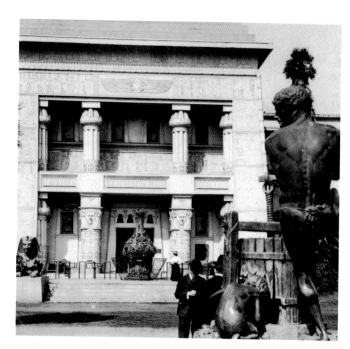

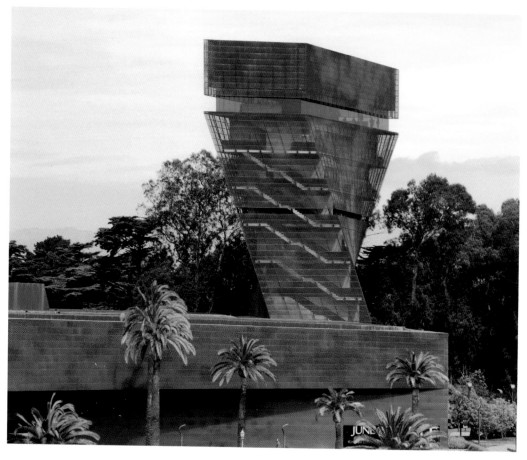

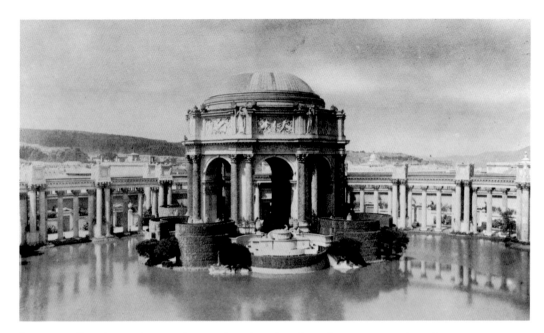

PALACE OF FINE ARTS: Clear minds prevailed when the Palace of Fine Arts, 3301 Lyon Street, was not destroyed after the Panama-Pacific International Exposition in 1915. San Francisco hosted the exposition in honor of the completion of the Panama Canal, and to celebrate the city's resurrection after the 1906 disaster. Architect Bernard Maybeck chose a design to resemble a Roman ruin and we can still gaze on a great rotunda of a Roman Classical character, with Corinthian columns and carefully detailed cornices, placed on two out-curving colonnades. The Place of Fine Arts' beauty continues to grace surrounding neighborhoods and is available as an event venue and theater. [T: LOC] [B: LOC/CHA]

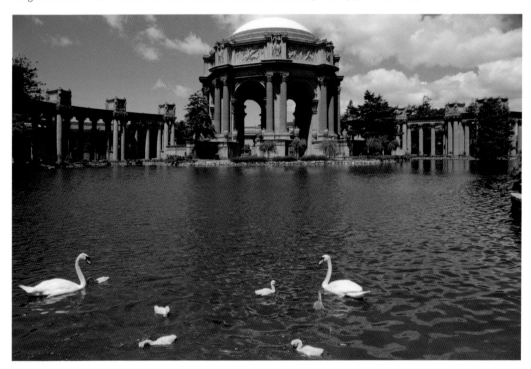

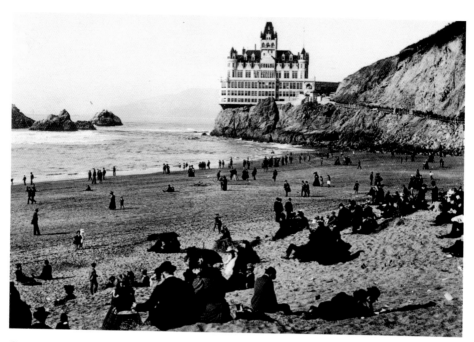

CLIFF HOUSE & OCEAN BEACH: The cliff house sits alongside the Pacific Ocean, as the second of five incarnations since its beginnings in 1858. This image of the iconic structure was taken from Sutro Heights in 1907. Built in 1896 by Adolph Sutro, it boasted eight stories fashioned after a French chateau some called "the Gingerbread Palace." It sat below his estate on the bluffs of Sutro Heights for only eleven years before burning down in 1907. With four spires and an observation tower 200 feet above sea level, it served as an elegant site for dining, dancing, and entertainment. The current Cliff House restaurant is perched on the headland above the cliffs and is part of the Golden Gate National Recreation Area. [T: LOC] [B: CA]

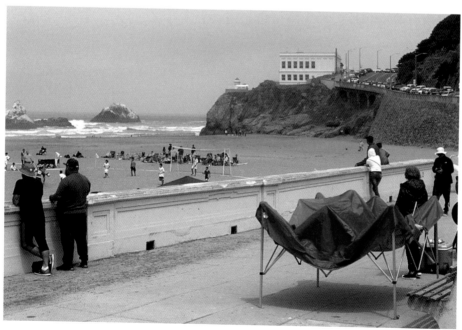

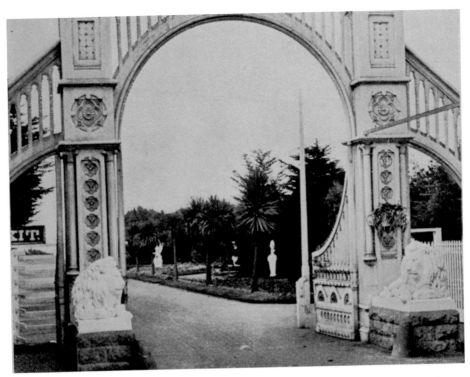

SUTRO GARDENS ENTRANCE: Sutro Heights was the location of the Sutro estate, the 18-acre city estate of Adolph Sutro, Comstock Lode silver baron, and major San Francisco landowner. His grounds at Lands End near the Cliff House included a spacious turreted mansion, a carriage house, and outbuildings set in expansive gardens with this elaborate entrance gate. Although the major structures are gone, the estate lives on as a popular city park. [T: LOC] [B: CA]

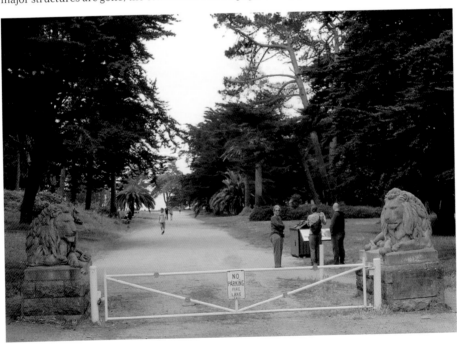

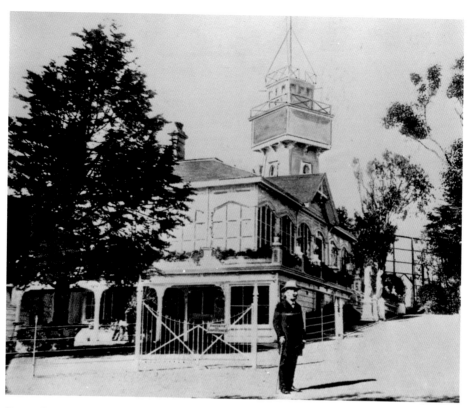

SUTRO HEIGHTS HOUSE: The Sutro mansion dominated the estate, which was surrounded by a million dollars' worth of a recreated Italian-style gardens filled with fountains, planted urns, and statues, Victorian flower beds, hedge mazes, trees, a glass plant conservatory, and other garden structures. What remains is this gazebo. [T: LOC] [B: CA]

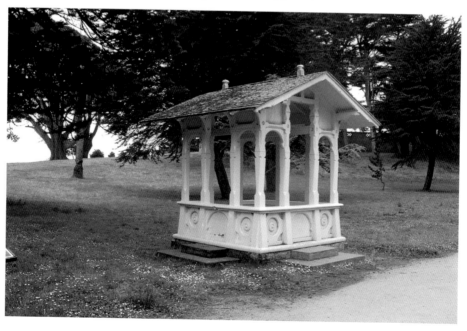

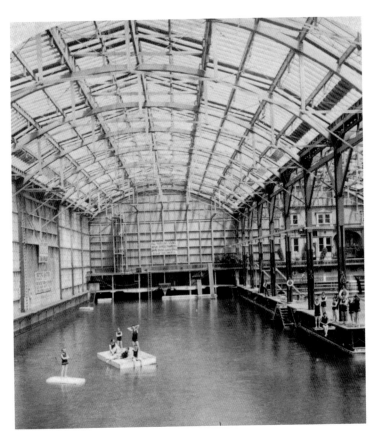

SUTRO BATHS:
These, the largest indoor baths in the world, were the vision of wealthy, former mayor of San Francisco, Adolph Sutro. Clinging to rocky outcroppings, this amazing glass-roofed structure contained seven saltwater swimming pools, fed by the powerful tides at the entrance to San Francisco Bay. Burning to the ground in 1966, the ruins are now a haunting reminder of San Francisco lost.
[T: LOC] [B: CA]

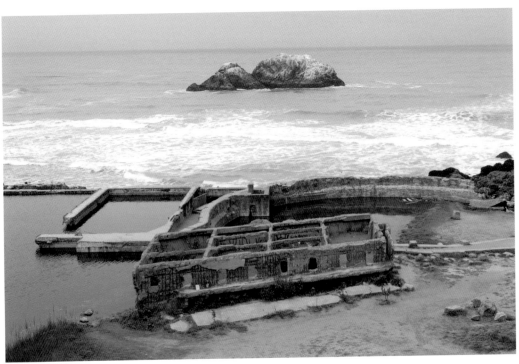

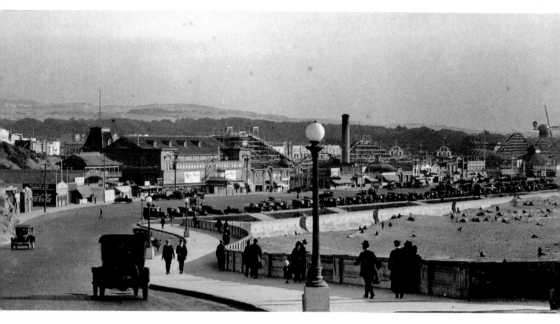

PLAYLAND AT THE BEACH: We are looking towards Playland at the Beach in the 1930s. The amusement park, across the Great Highway from Ocean Beach, was a stellar example of frolicsome San Francisco. Originally, the Ocean Beach Pavilion opened at this location in 1884, and in 1912, Arthur Looff and John Friedle built Looff's Hippodrome, housing a grand carousel. In 1921, this was the site of a popular water ride called the Chutes, and in 1922, the Big Dipper wooden roller coaster was added. The Whitney Brothers purchased the park in 1928 and renamed it Playland at the Beach. George Whitney was often called the Barnum of the Golden Gate. [T: SFPL] [B: CA]

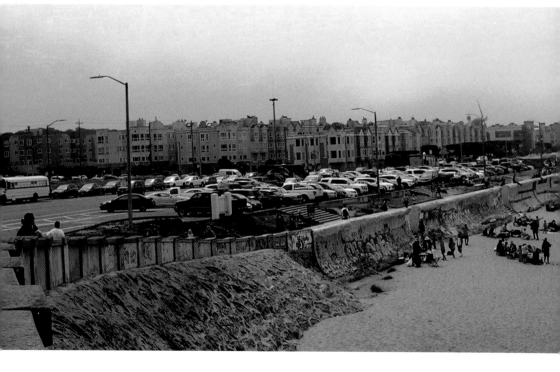

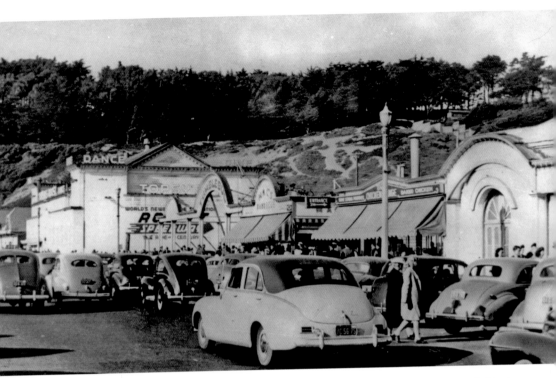

PLAYLAND'S AMUSEMENTS: This is just a glimpse at the many enjoyable delights that were available at this beloved amusement park. Besides the Chutes and the Big Dipper, in 1923, a larger Fun House was added. After providing decades of fun and fond memories, Playland closed in 1972. The land purchased by developers and is now the location of condominium complexes. [T: SFPL] [B: CA]

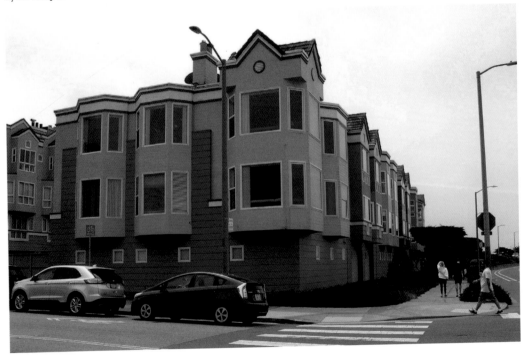

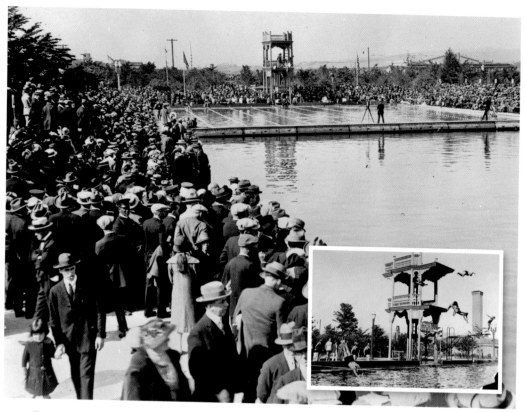

FLEISHHACKER POOL: Back in 1925, people enjoyed this spectacular pool located off the Great Highway for forty-seven years. One of the favorite attractions was the popular diving structure. Bathers could frolic in salt water pumped from the Pacific Ocean in a pool that measured 1,000 by 150 feet, held 6,500,000 gallons of seawater, and accommodated 10,000 bathers. The pool is now covered over in concrete and serves as a parking lot. [Top Two: LOC] [B: LOC]

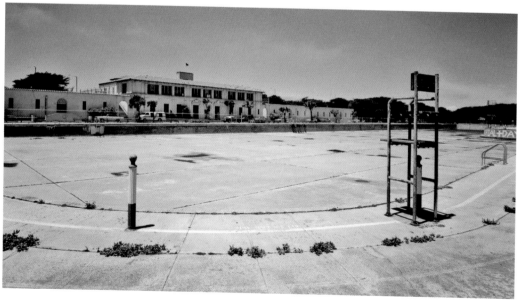

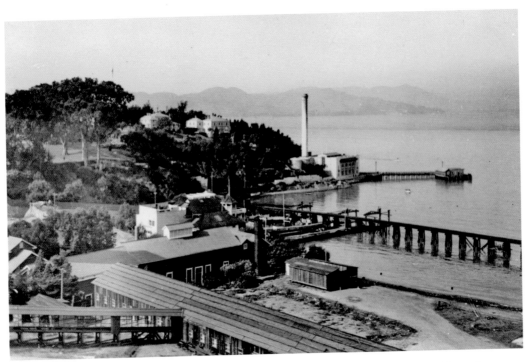

BLACK POINT: We are looking west at Black Point and the entrance to San Francisco Bay in December 1920. Located near Bay, Van Ness, and Laguna Streets, the area garnered the name due to its dark vegetation. During the Civil War, the Point was taken over by the military for defense purposes and renamed Fort Mason, becoming the U.S. Army San Francisco Port of Embarkation. Fort Mason has since become part of the Golden Gate National Recreation Area. [T: LOC] [B: CA]

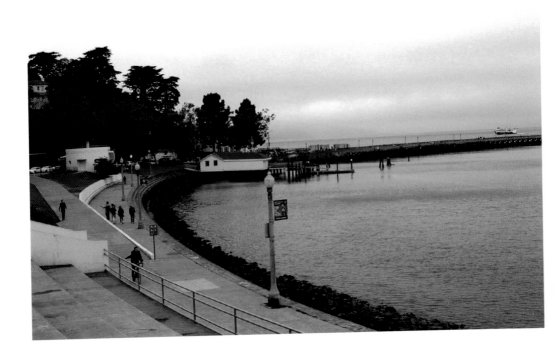

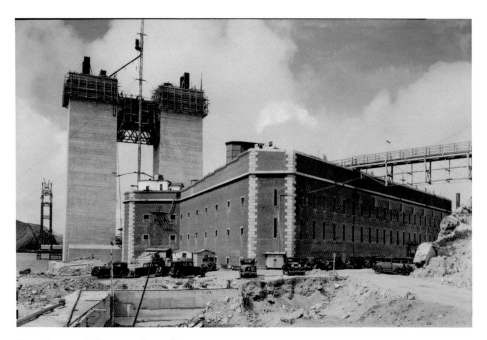

FORT POINT & GOLDEN GATE BRIDGE: Nested adjacent to the bridge, this masonry seacoast fortification was built 1853-1864. It is also the geographic name of the promontory upon which the fort and the southern approach of the Golden Gate Bridge were constructed. Covering 290 acres and overlooking the Golden Gate, the fort protected San Francisco harbor from attack through the Gold Rush, the U.S. Civil War, and World War II. These landmarks structures continue to majestically mark the entrance to San Francisco Bay. [T: LOC] [B: CA]

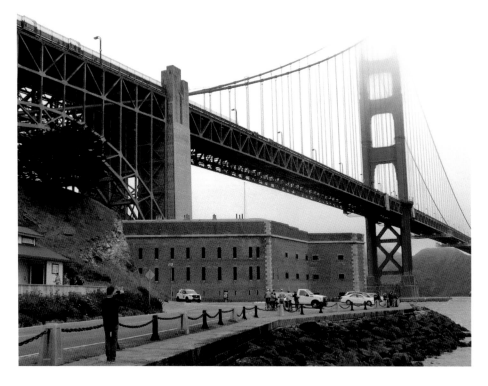

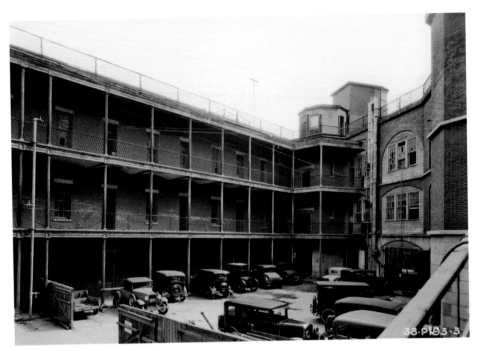

FORT POINT INTERIOR: The inside court of the fort as it looked filled with automobiles on May 31, 1934. The fort is now part of the United States National Historic Site administered by the National Park Service as a unit of the Golden Gate National Recreation Area. [T: LOC] [B: LOC/CHA]

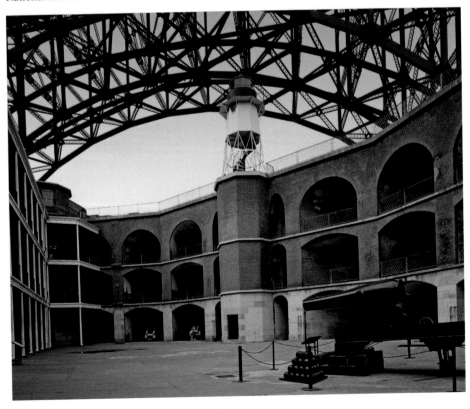

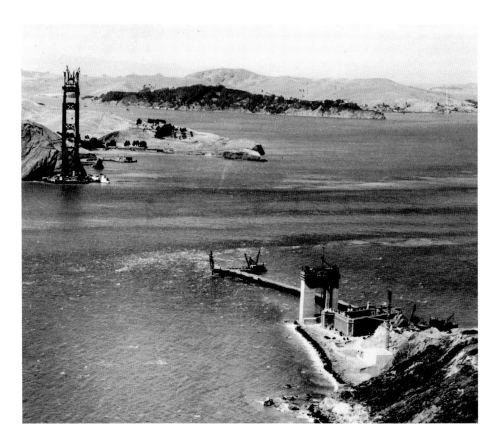

GOLDEN GATE BRIDGE: This iconic structure is an official San Francisco and California landmark. The bridge is named for the Golden Gate Strait, the entrance between the Pacific Ocean and San Francisco Bay. Construction began in 1933, ended in 1937, and was dedicated on May 27, 1937. Engineer Joseph Strauss and architect Irving Morrow created a spectacular international landmark in a magnificent setting. The 4,200 feet of span between two towers was the longest bridge in the world until 1959. Well known as a marvel of engineering and art, the Golden Gate symbolizes San Francisco around the world. [T: LOC] [B: LOC/CHA]

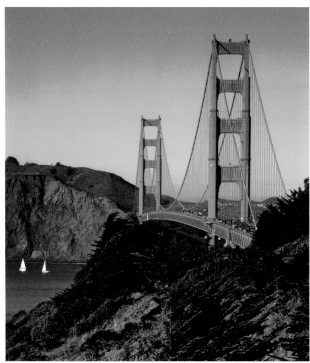

PHOTO CREDITS

Photographic credits are indicated at the end of each caption and identified as top/historic photograph [T] or bottom/contemporary photograph [B].

Sources of historic photographs are identified as follows:
Library of Congress, Prints & Photographs Division [LOC]
San Francisco History Room, San Francisco Public Library [SFPL]
Richard Monaco-J. B. Monaco Collection, San Francisco Public Library [JBM]

The Monaco images were graciously donated directly to the author by Richard Monaco.

Contemporary photographs are by the author as indicated by [CA].

The exceptions are the photographs by Carol H. Highsmith as indicated by [LOC/CHA]. Ms. Highsmith's photographs are courtesy of the Library of Congress, Prints & Photographs Division, Carol M. Highsmith Archive.